This Book Belongs to

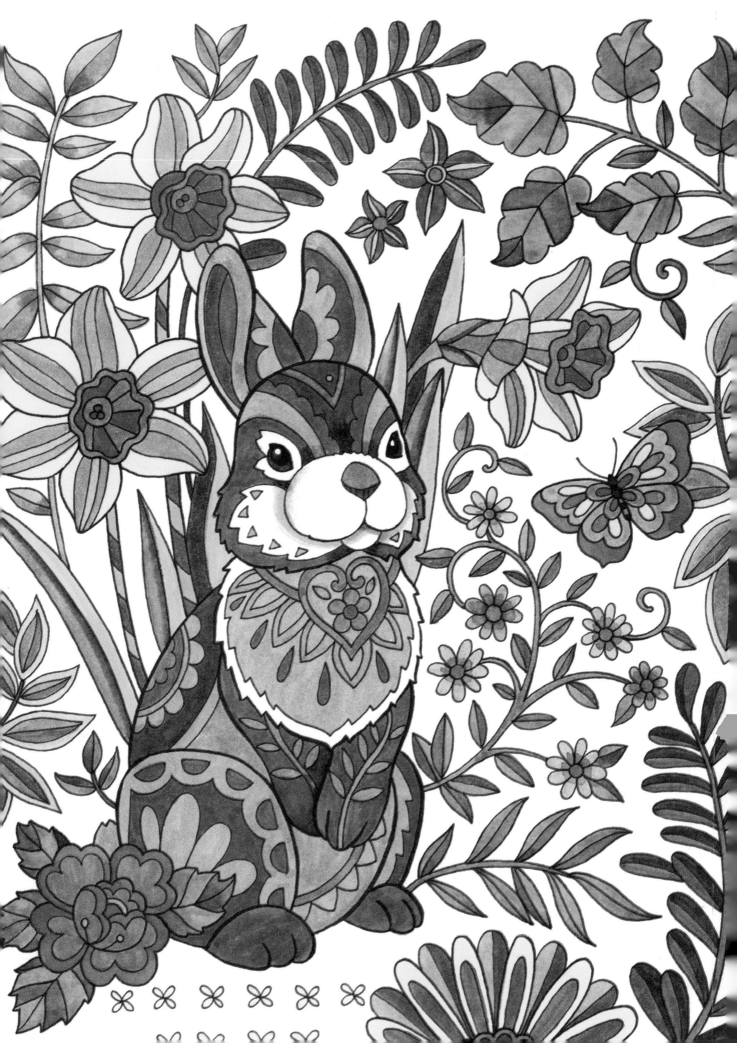

COLOR
super cute
ANIMALS

⊱ Jane Maday ⊰

NORTH LIGHT BOOKS
CINCINNATI, OHIO
www.artistsnetwork.com

❀ CONTENTS ❀

⇒⇒ INTRODUCTION ⇐⇐

Coloring is such a wonderful activity, because it is a way for people of any age to find relaxation and to express their creativity. You don't need expensive equipment or artistic experience. You can choose whichever materials suit your fancy, such as colored pencils, crayons, gel pens or markers. I don't recommend using watercolor in this book because excess moisture will cause the paper to buckle.

There is no right or wrong way to color in this book though. You can choose whatever colors you like. A purple elephant or pink bunny? Great! Feel free to experiment with the different shading techniques I discuss on the next few pages. Shading is a wonderful way to add depth to

your artwork. The drawings vary in complexity, and you can add your own doodles with black pen if you wish, and they are only on one side of each page, so you can cut them out for framing or crafting.

Some people find coloring to be a meditative activity. It can be the calming end to a busy day. My sister likes to settle down after a day's work with her favorite music, a candle, a glass of wine and her coloring book. Sounds perfect to me!

The drawings are all based on my love for nature and our beautiful world. I am so happy that we will be creating artwork together. Now gather your favorite colors and let's get started!

❧ TOOLS AND MATERIALS ❧

It is such fun to be able to express yourself in color! There are lots of options for coloring supplies. These are my favorites, but you might have others that you prefer. There are no set rules for coloring in this book!

1. Colored pencils. Colored pencils come in a huge variety of colors and types. There are fun ways of blending and shading that I will show you. There are also watercolor pencils that can be smoothed out or blended with a damp paintbrush. Keep water to a minimum to avoid the paper buckling.

2. Watercolor markers. I like markers with brush tips, like these Sakura Koi coloring markers. They work just like a paintbrush. The ink is water soluble, so you can blend them with a damp paintbrush. You can also get a special colorless blending marker to help make smooth color transitions. Some markers come with dual tips: a brush nib at one end and a fine point nib at the other end. One thing to consider when buying markers is if they are lightfast. Choose artist quality rather than student or children's markers if you don't want them to fade.

3. Alcohol-based markers. Alcohol markers, like those from Copic, are not water-soluble. They come in a wide assortment of colors, and you can also purchase a colorless blender. Be

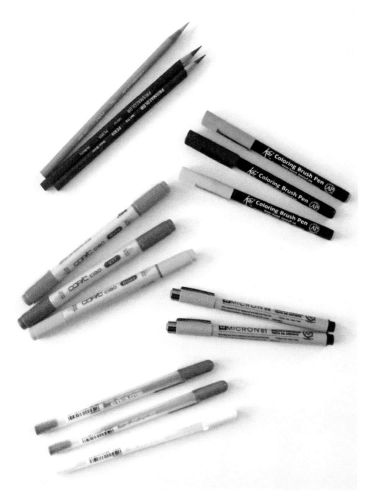

careful using a colorless blender with either watercolor or alcohol markers, as too much rubbing will cause the paper surface to pill. This is less of a problem with alcohol markers as they don't soak into the paper as much.

When using markers, the color may bleed through the paper. The designs are only printed on one side of each page, but you will still want to place a sheet of clean paper underneath so it doesn't soak through to the next picture.

4. Black liner pens. You can use black fine point pens, such as Pigma Microns, to add your own doodles and details to the designs, if you wish. The pens come with different size nibs. Typically .005 is the smallest and 1.0 is the largest. The designs in this book were drawn with a brush marker, a .05 and a .01.

5. Gel Pens. Gel pens, like Gelly Roll pens from Sakura, are a type of paint pen. You can draw fine lines and details and the colors are bright and opaque. Gel pens and markers work well together, as you can use the marker to fill in a large area and then add details over the top with gel pens. I think it is especially nice to do this with an opaque white gel pen. Make sure your marker layer is completely dry before you try this.

❀ COLOR BASICS ❀

The human eye can distinguish millions of colors, so the possibilities for color selections are endless.

Below is the color wheel. You can see the primary colors—red, yellow and blue. Next come the secondary colors, created of a mix of two primary colors (red+blue make violet, red+yellow make orange, and yellow+blue make green). Finally, you have the tertiary colors, which are made by mixing a primary color and a secondary color. They are blue-green, yellow-green, red-orange, etc.

You can make further colors by tinting and shading. Tinting means to add white to a color, which makes it lighter and more pastel in appearance. You can make pink, for example, by tinting red with white. Shading can be created by mixing in a touch of black (if using paint), or by using a darker value of a color. When coloring in a book like this, I think it is best to avoid black when shading; choose a darker value of your base color instead.

Colors also are also referred to as having temperature. "Cool" colors, such as blue and green and some purples have a calming, gentle effect. "Warm" colors such as red, yellow and orange convey bright emotions, passionate feelings and excitement.

COLOR PALETTES

It helps to plan out your color palette before you begin coloring your design. Different color palettes can evoke different moods.

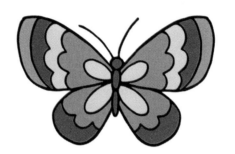

Monochromatic

A monochromatic color scheme means using tints and shades of the same color. For example, you could do an entire design in different blues or greens.

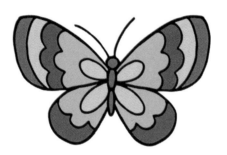

Analogous

An analogous color palette refers to using three colors that are side by side on the color wheel. These colors will always work harmoniously together. For example, you could use different tints and shades of yellow-green, green and blue-green.

Complementary

Complementary colors are two colors that are positioned opposite each other on the color wheel. This means a warm color will be paired with a cool one. They can make a nice, contrasting color palette, such as red and green.

ADDING DOODLES AND **DETAILS**

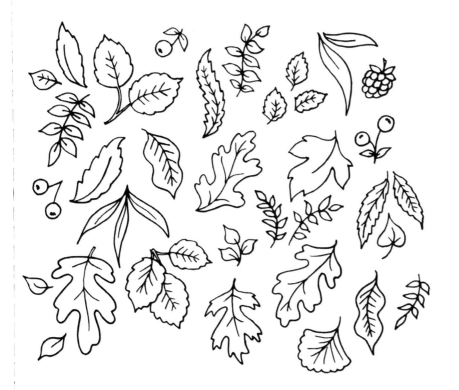

Some of the designs in this book are more simple than others. You may feel like you want to add your own touches with a fine-point pen, such as a Pigma Micron. Make sure whatever pen you use is waterproof and that your drawings are completely dry before you color them.

Natural Shapes

Leaves come in many shapes and sizes. Here are some ideas for leaves that you can add to the designs, if you wish.

More Doodles

You can also have fun with various doodle shapes and patterns. Here are some examples to get you started.

🌿 SHADING 🌿 AND **BLENDING** WITH **COLORED PENCILS**

Shading is a great way to add depth to your coloring. Choose one or two darker versions of your base color. If you wish to blend your colors for a smoother appearance, you can use either a colorless blender pencil (these look like a very pale gray colored pencil and are generally sold separately from colored pencil sets), or you can use a cotton swab moistened with baby oil. Make sure to only use a small amount of oil or you will make the paper greasy.

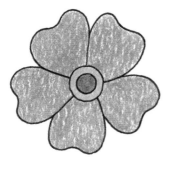

Color the Base

Start by filling in the shapes with your base color.

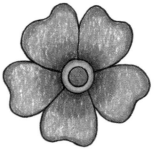

Add Shading

Use the darker color to shade the edges and middle. Coloring darkest towards the center and fading to the edges of the petals helps to add depth.

COLORLESS BLENDER PENCIL BABY OIL AND COTTON SWAB

Blend the Color

When you color with colored pencils, sometimes the texture of the paper shows through. Blending helps alleviate that. Here are examples of using a colorless blender pencil and using baby oil on a cotton swab. The cotton swab does pick up a little of the pigment with this method. You can also use a white colored pencil for blending, but this will lighten your colors a little.

Add Details

You can also add extra shading and details using a fine point black marker pen. I used a .01 Pigma Micron pen here. If you are using a pen on top of your colored pencil drawings, make sure to wipe the tip frequently on a sheet of scratch paper to clean the nib. I usually add my extra details first, before using the colored pencils, just to make sure that the nib stays clean.

⇛⇛ SHADING ⇚⇚
AND **BLENDING**
WITH **WATER-BASED**
MARKERS

Markers lay on the paper smoothly, and very little of the paper texture shows through. Some markers are juicier than others, so make sure to place a sheet of scrap paper underneath your coloring page, in case it soaks through. When coloring and blending, be careful not to layer or rub too much, as the paper may pill (become rough and lumpy). The actual marker color often varies from the color of the cap, so it is a good idea to test your marker on scrap paper first.

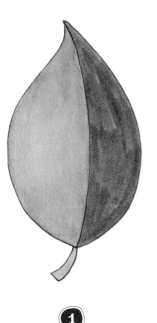

①

Add Base Colors

To shade this leaf, start by choosing a light, medium and dark green color. Leaves usually have one side that is turned to the light, so color one side with your lightest green and the other side with the medium green.

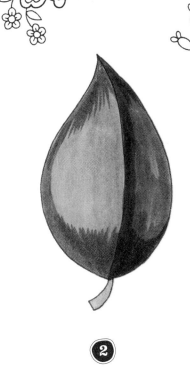

②

Add Shading

Use the darkest color to add shading along the edges of the medium-colored side, and use the medium tone to shade along the lighter side.

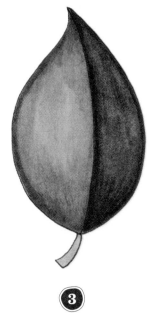

③

Blend with a Colorless Blender

To blend with a colorless blender, use delicate, featherlike strokes. Don't rub or scrub. Work from the darkest area to the lightest. To clean your blender when you are done stroke it across a piece of scrap paper a few times.

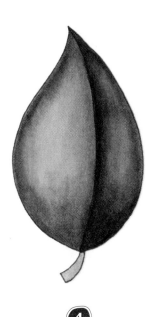

④

Blend with Water

To blend with water (when using watercolor markers), use a damp brush with a good point. Don't use too much water.

❦ USING ❦ WATERCOLOR MARKERS LIKE PAINT

This is a fun technique you can try if you feel like being more painterly. You need a colored watercolor marker (a darker color is best), a colorless blender and an acrylic block (sold for stamping) or a plastic marker-blending palette. Even a plastic lid from something like a margarine tub will do.

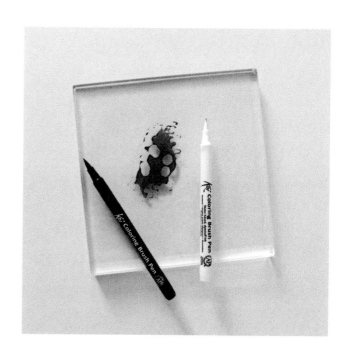

Color with your marker onto the acrylic block. This will leave a puddle of pigment. Use your colorless blender like a paintbrush to pick up some of the pigment. When you color your design, the color will automatically blend from dark to light. Start at the darkest area and work outward.

You can also blend one color into another with this method. Start at one end with one color and blend toward the middle. Then start at the other end with your second color, and blend that toward the middle.

When you are finished, clean your colorless blender by stroking it on a piece of scrap paper, and clean your palette by wiping it with a damp tissue.

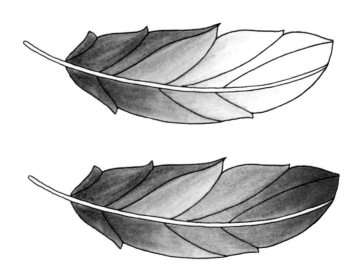

COLORING WITH ALCOHOL-BASED MARKERS

I like markers from Copic. They are generally considered to be the best when it comes to alcohol markers. They are quite expensive, though it helps that they are refillable and the nibs are replaceable. Blending without pilling the paper is a bit easier with alcohol markers as the ink sits more on top of the paper, rather than soaking in. Still, you want to work fairly quickly while blending, because once the ink is completely dry it will not blend as smoothly.

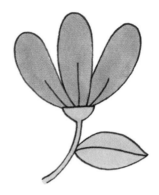

① Color the Base

Pick a light color and one or two dark colors to use on your design. Begin by coloring with the light color.

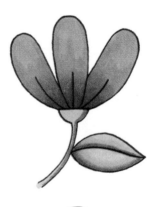

② Add Shading

Shade with light feather strokes, using the darker color. Then, with the lighter color, go back over the darker edges to smooth them out. You can also use a colorless blender for this. The alcohol in the ink acts as a solvent to help the colors blend. Try not to go over the same area too much or the color will start to bleed outside the lines.

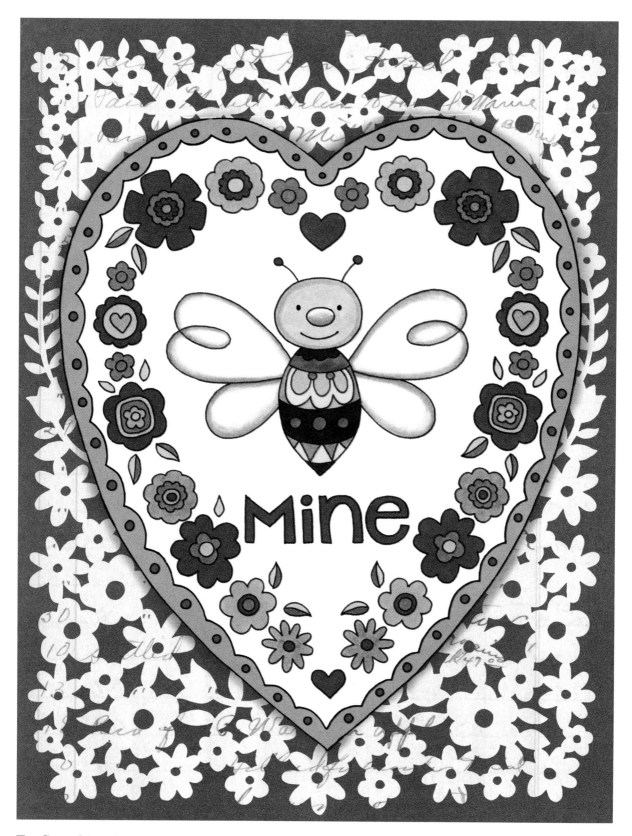

Try Something New

On this design, a fun alternative to coloring the whole thing is to use the border as a template for paper cutting. Trace and transfer the border design onto a sheet of decorative paper. Using a sharp craft knife (be careful!), cut away the spaces between the design. Next, mount the cut-out onto a sheet of colored paper. Finally, color the bee in the heart, cut it out and mount it on top of the border. What a fun gift for someone you love!

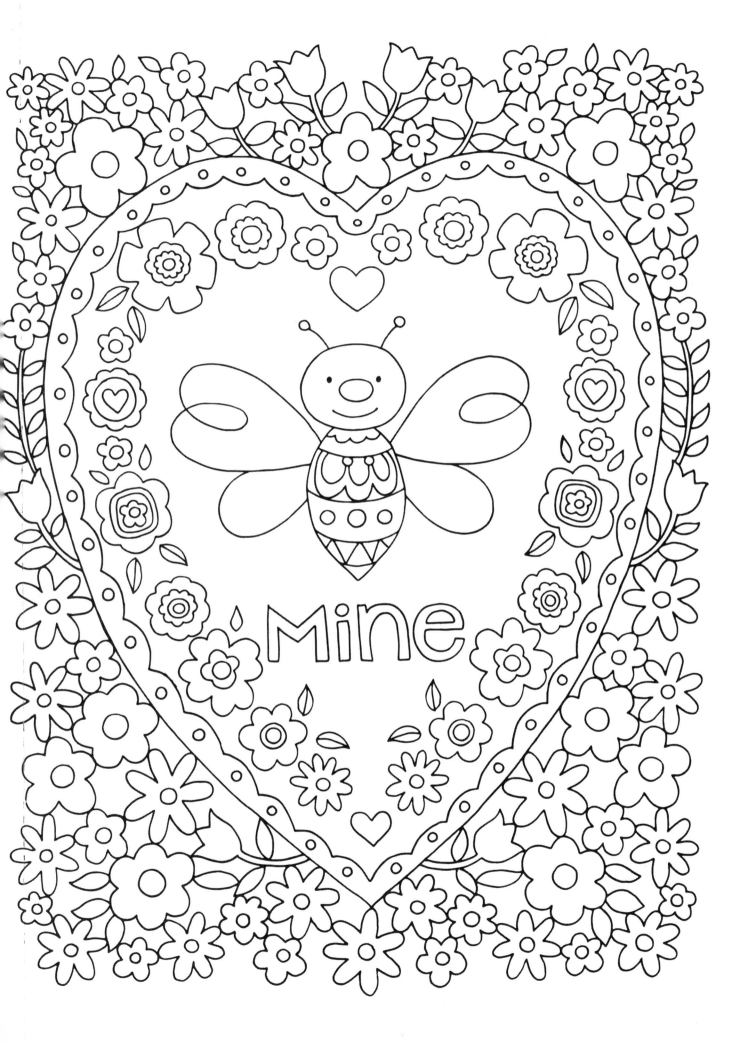

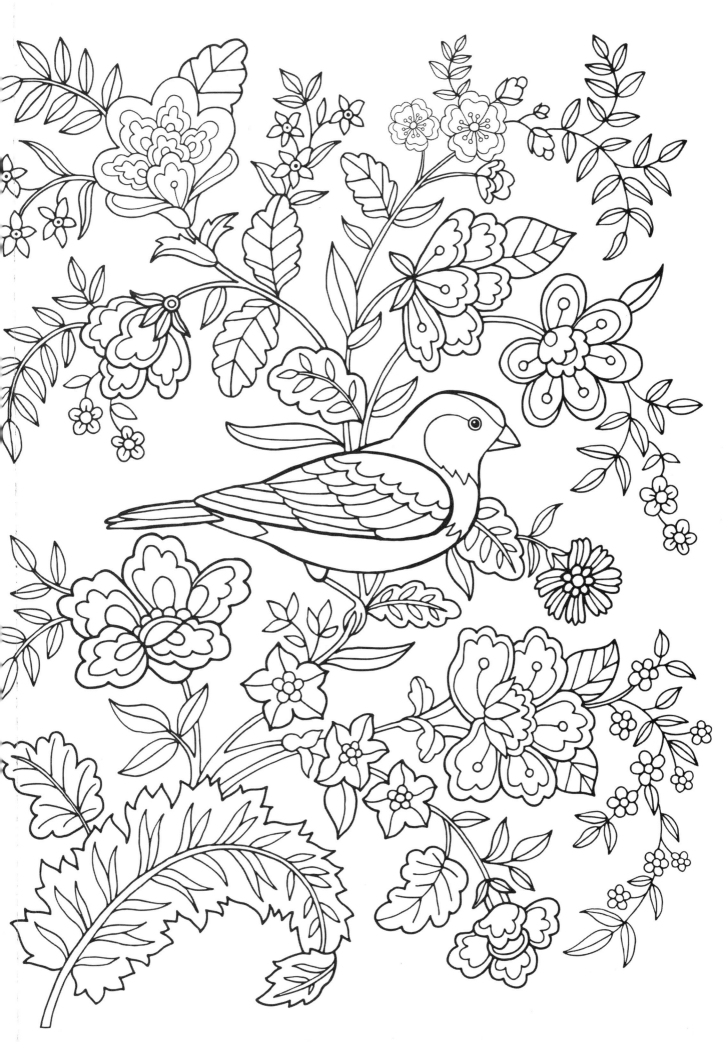

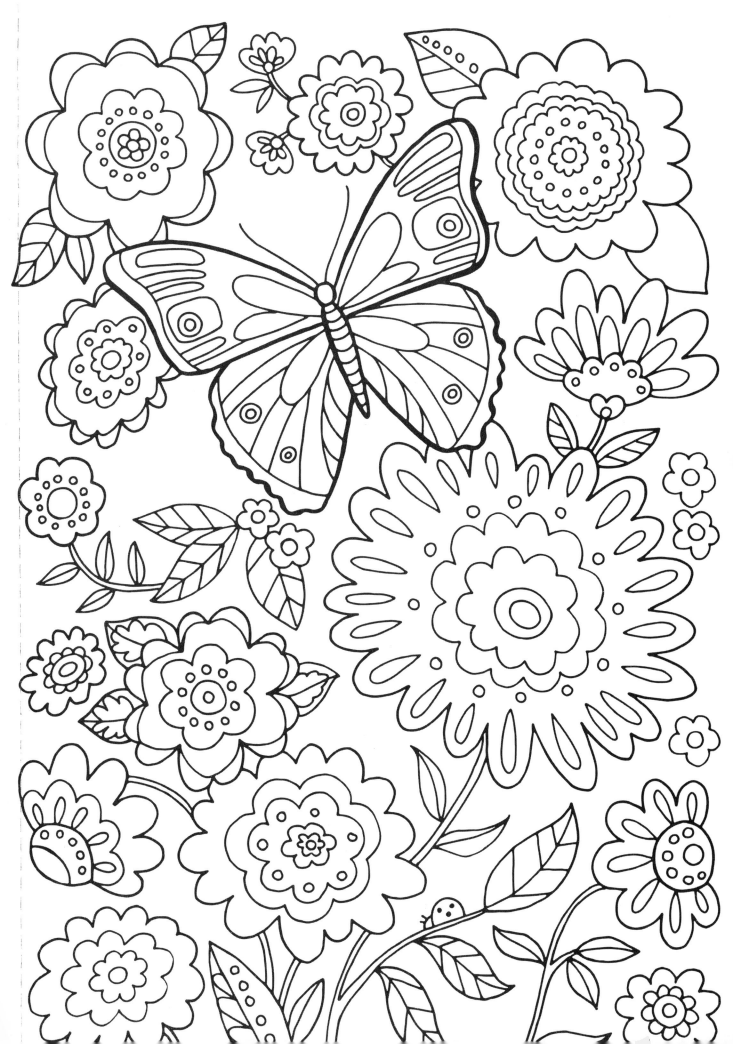

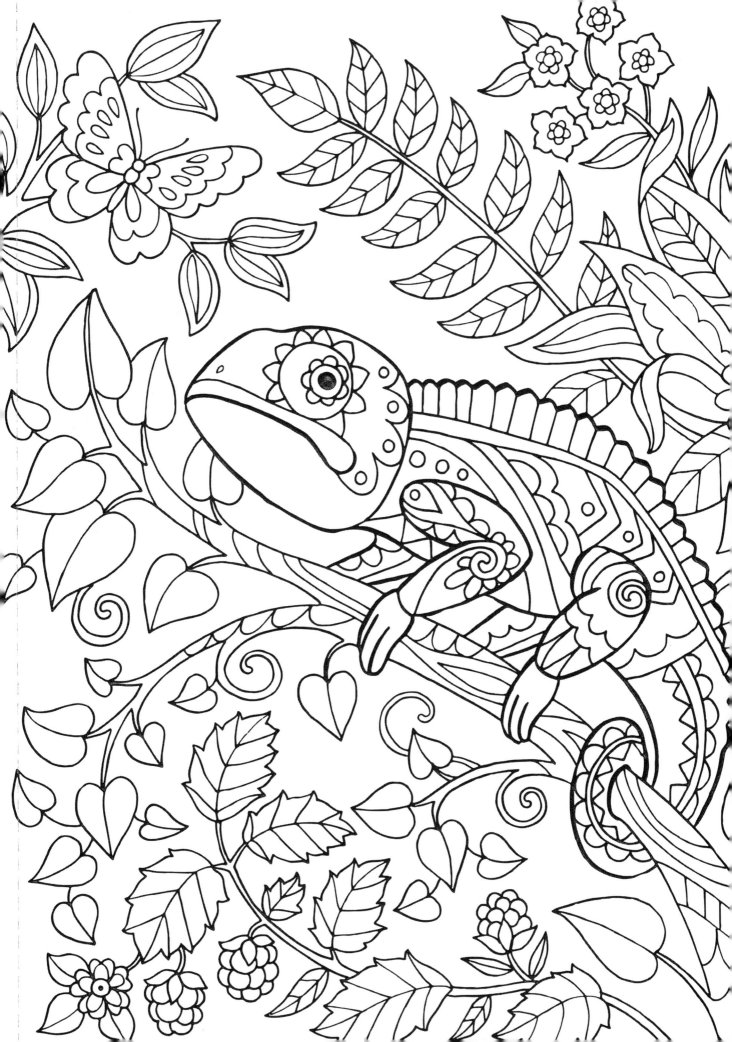

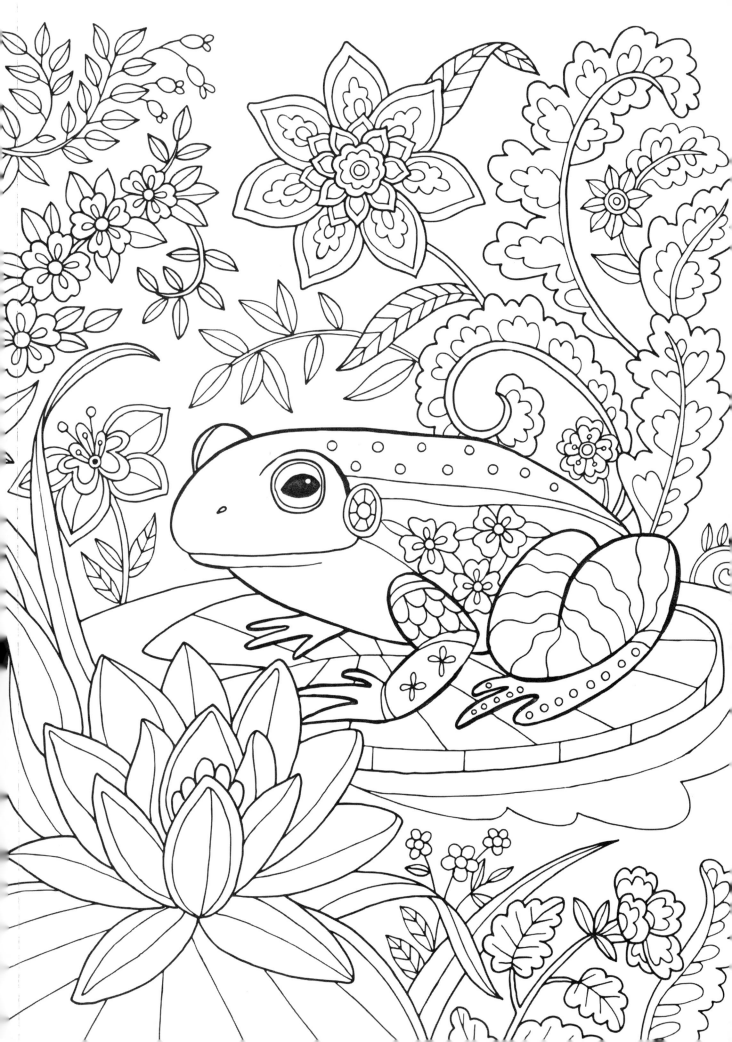

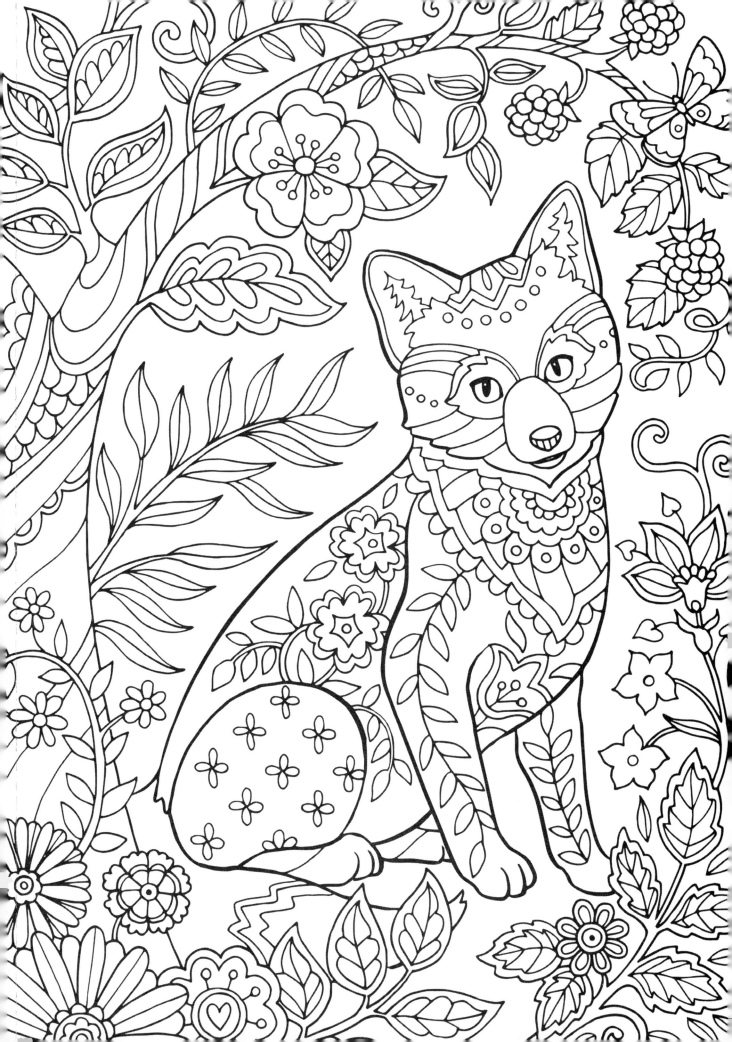

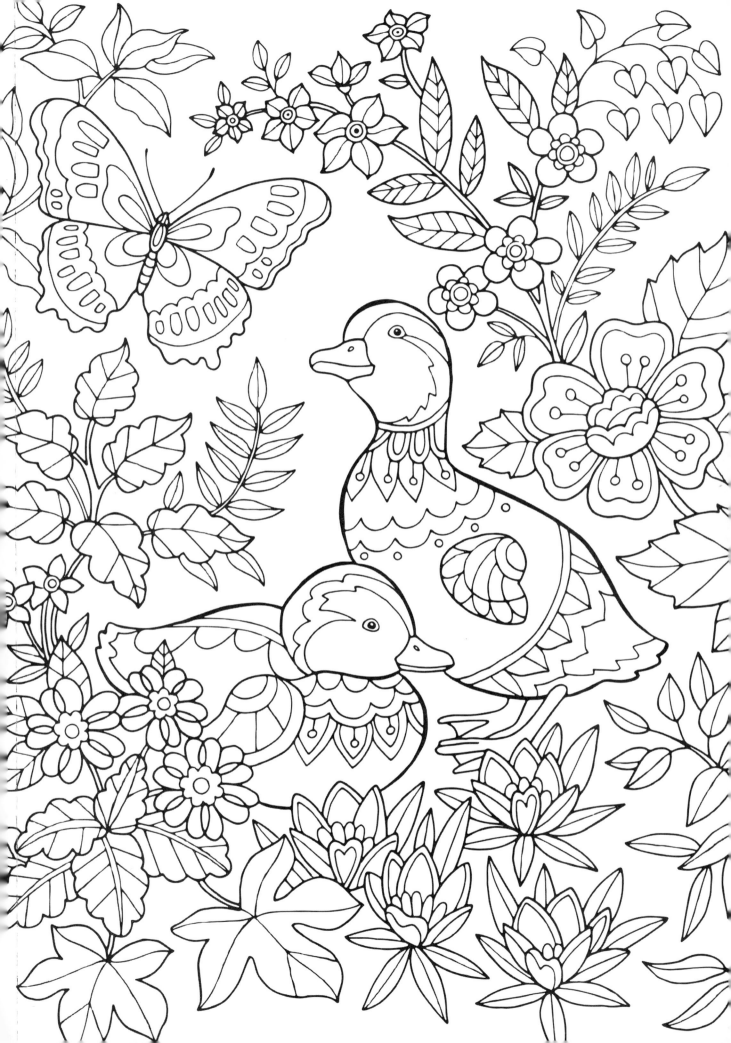

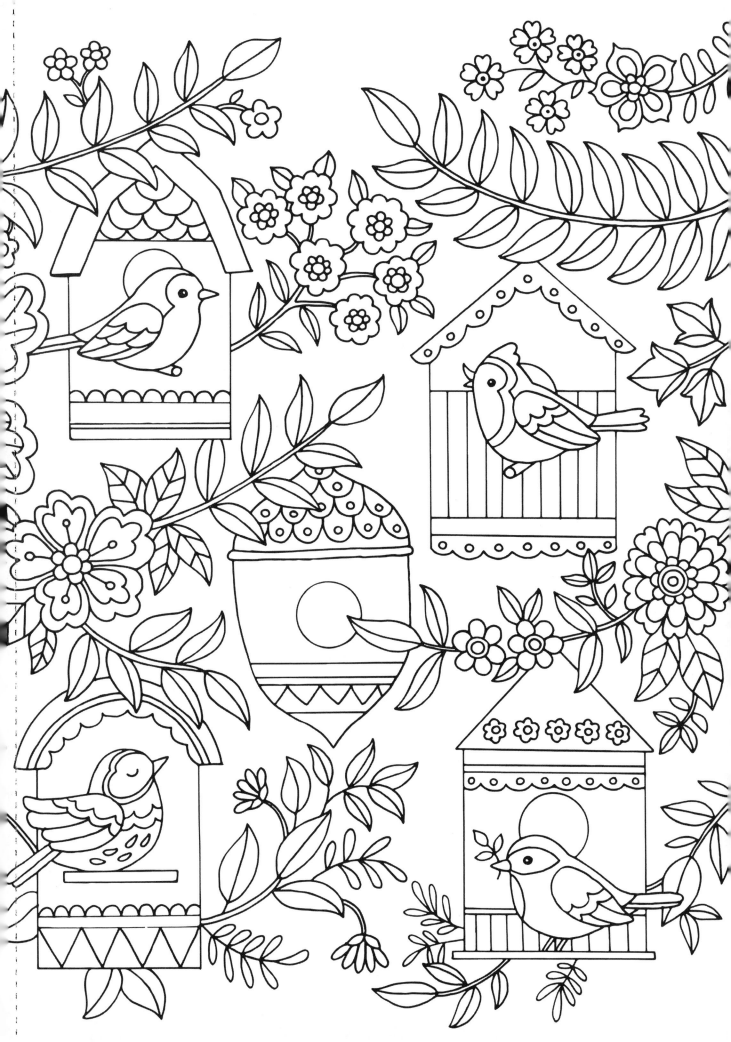

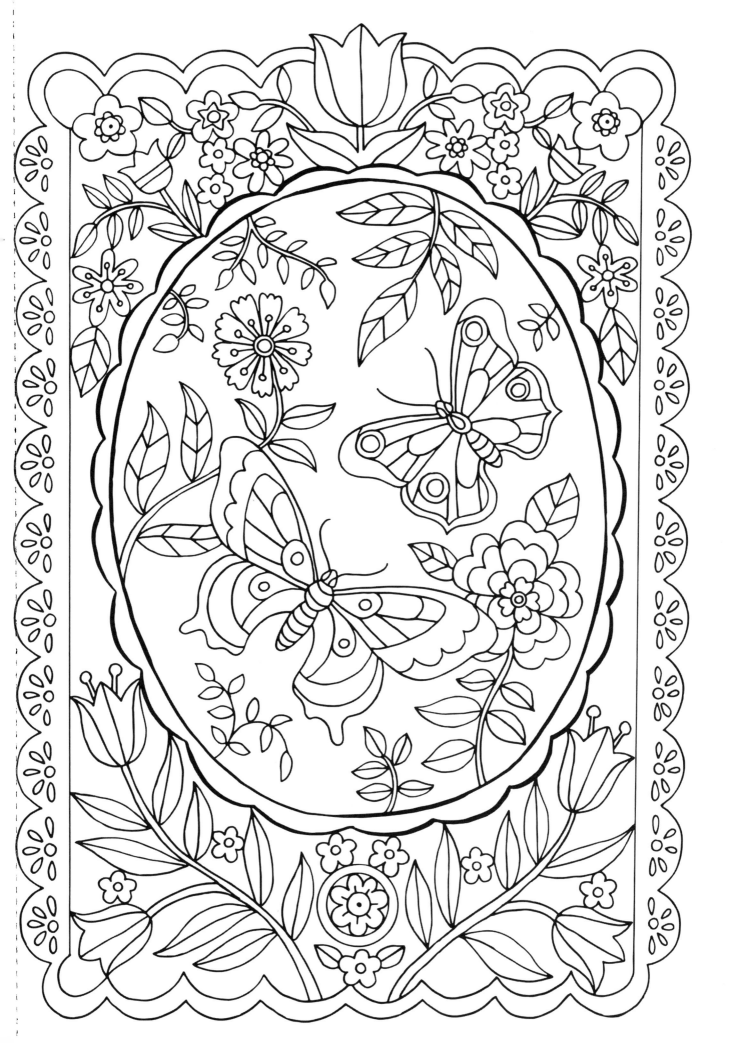

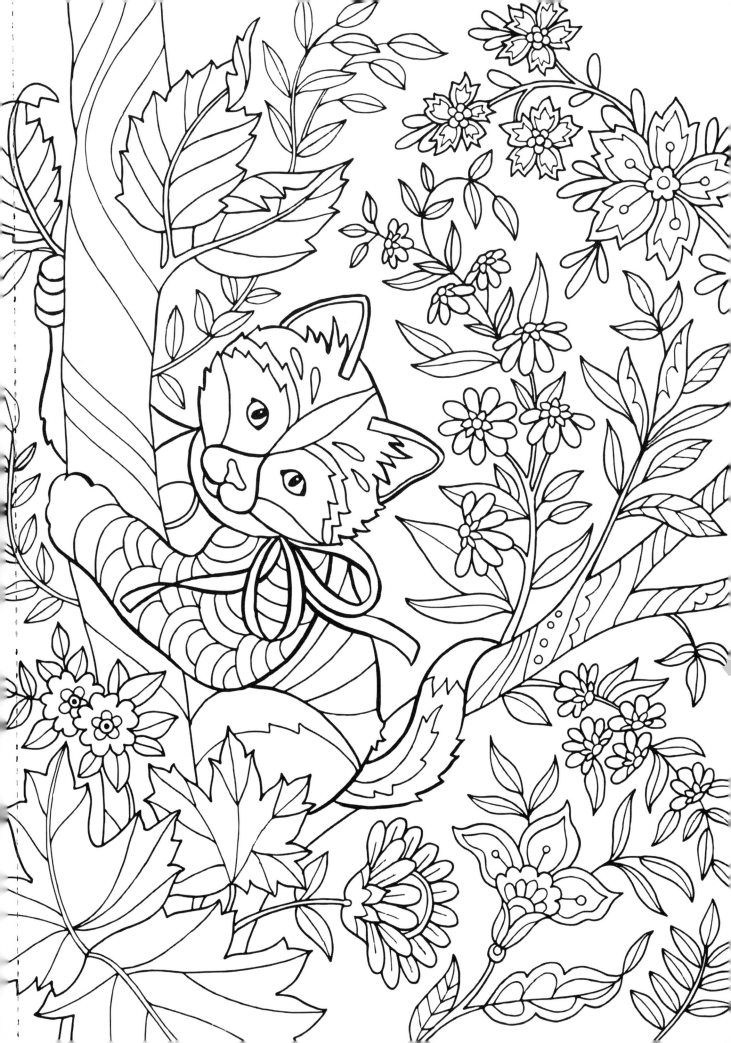

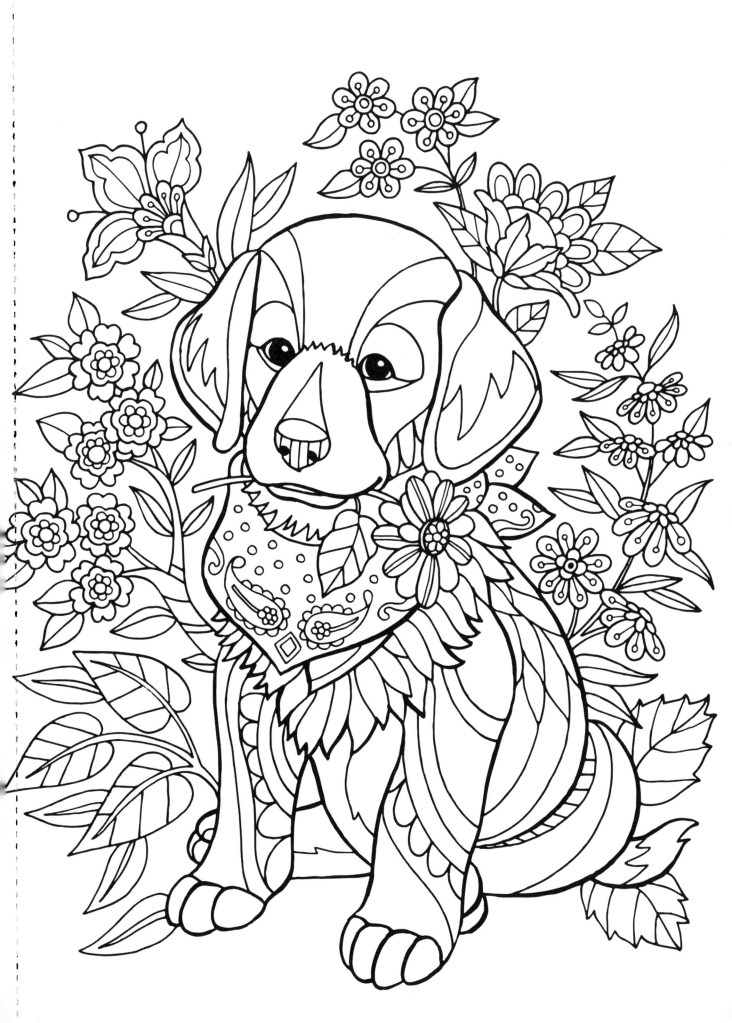

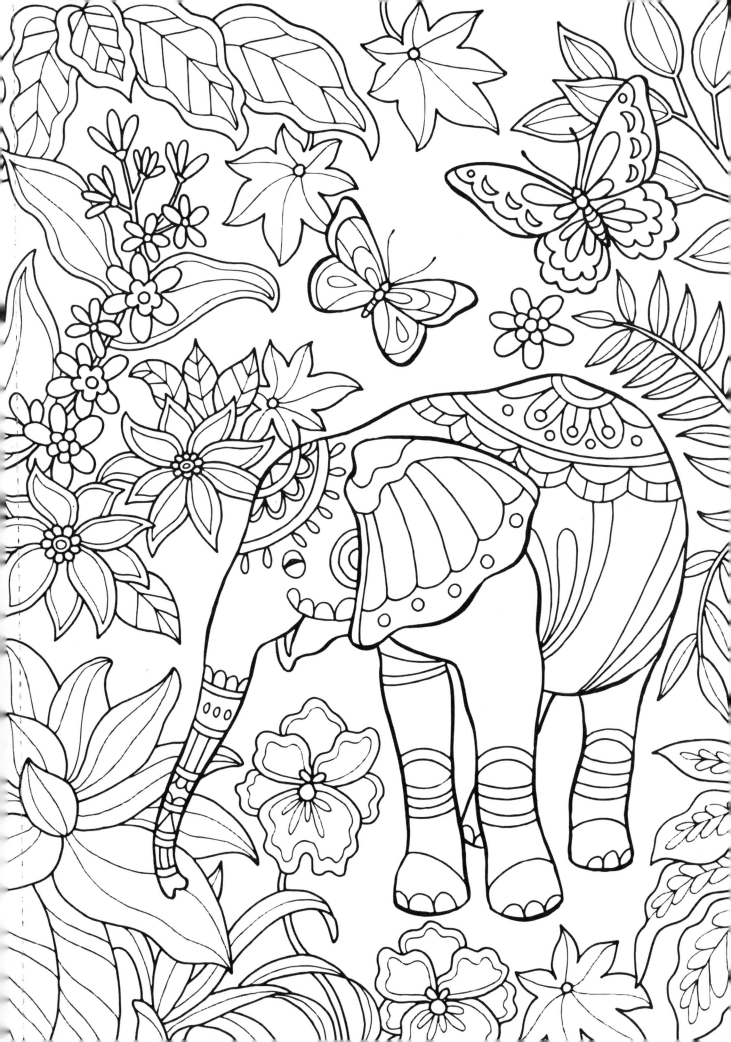

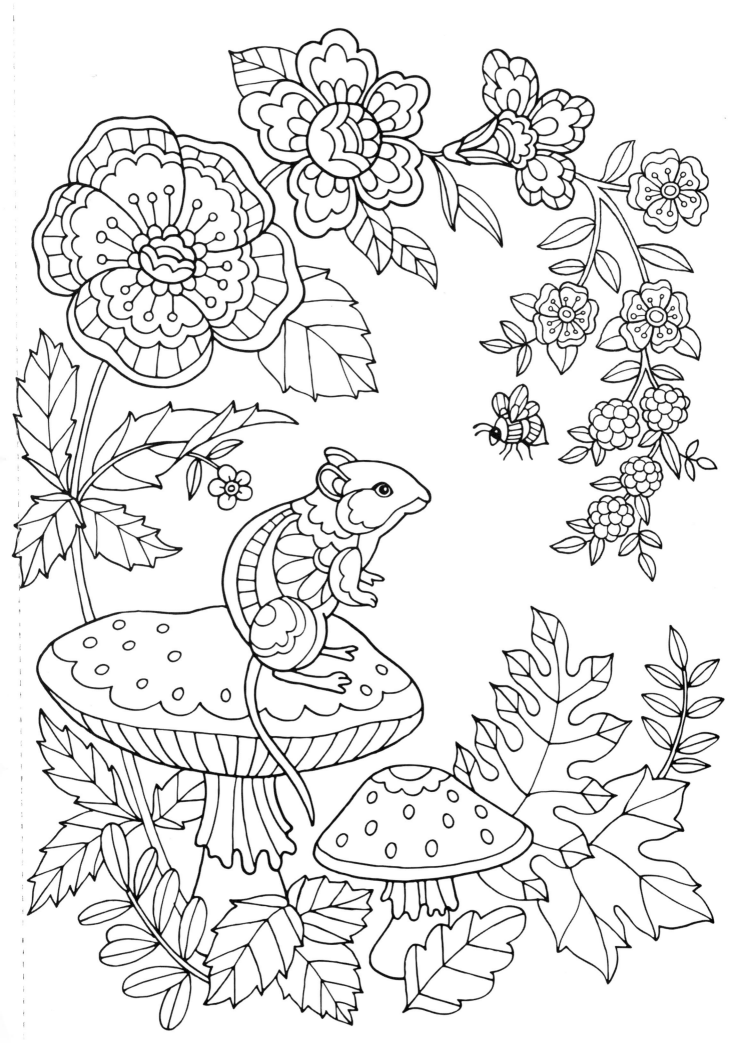

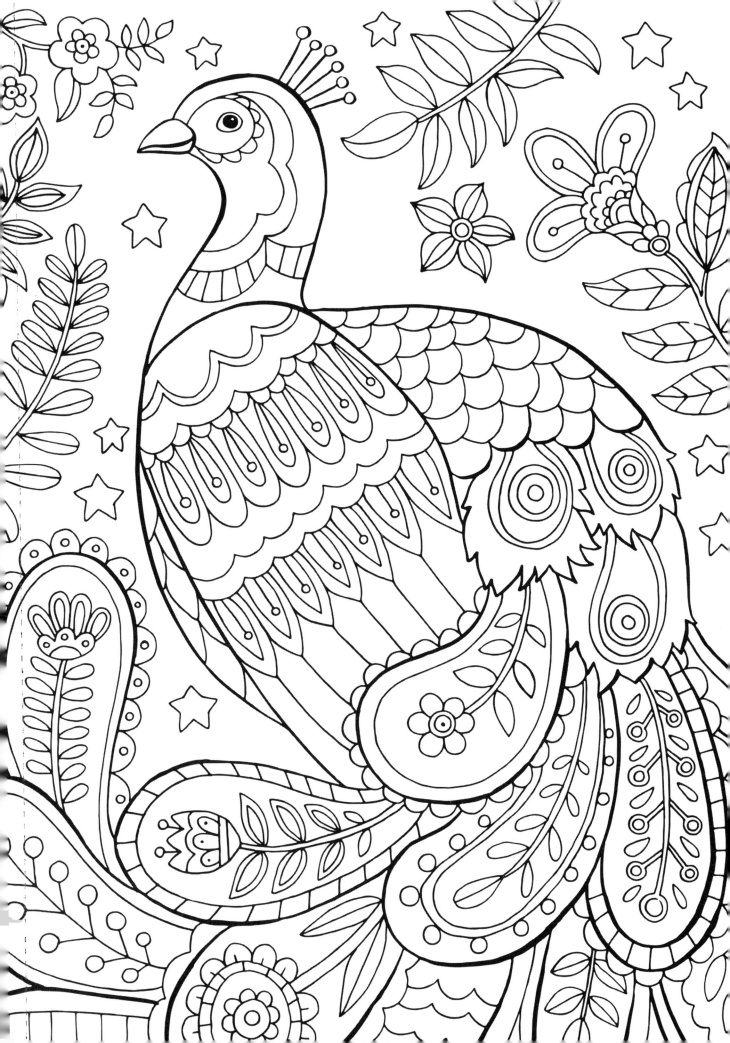

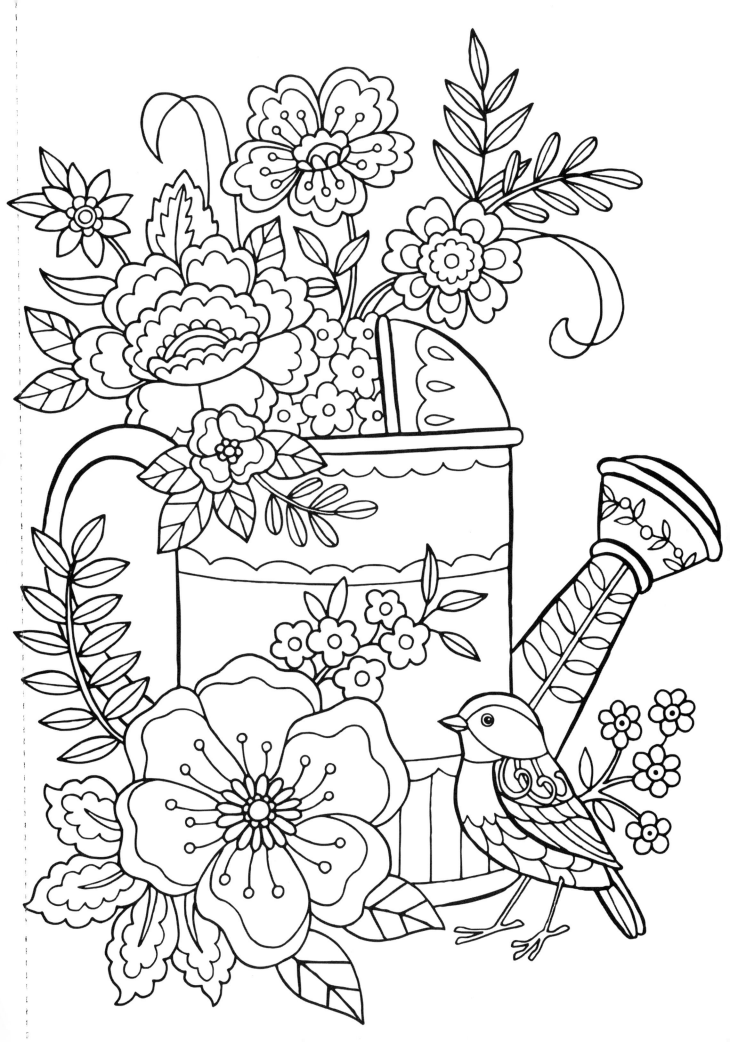

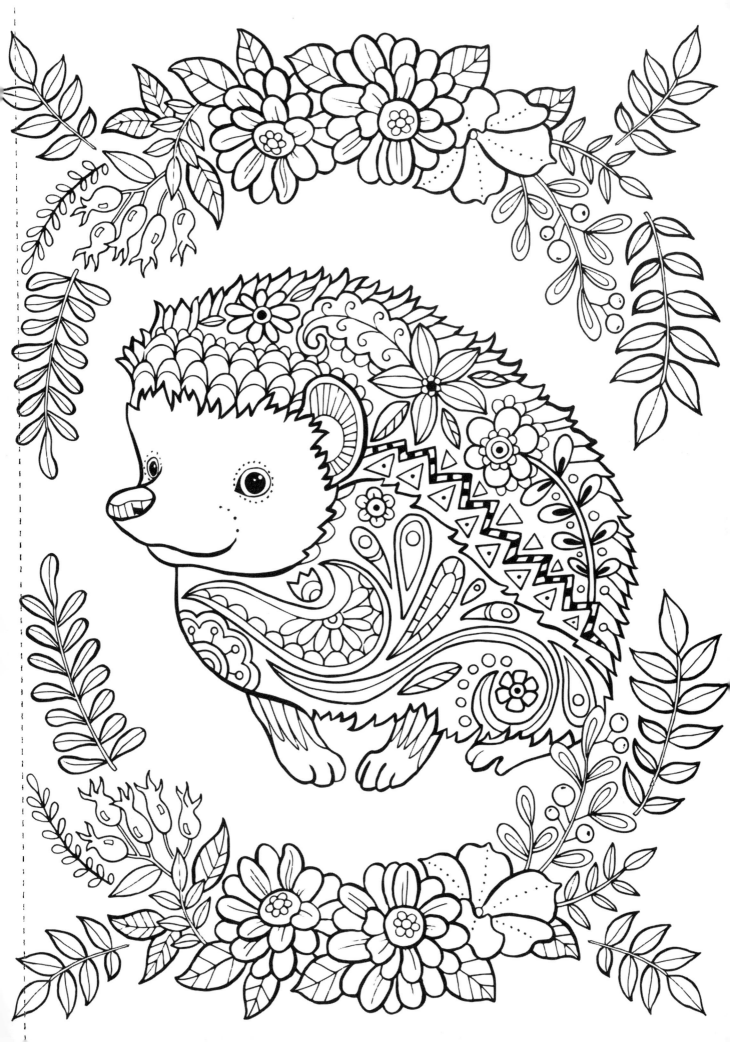

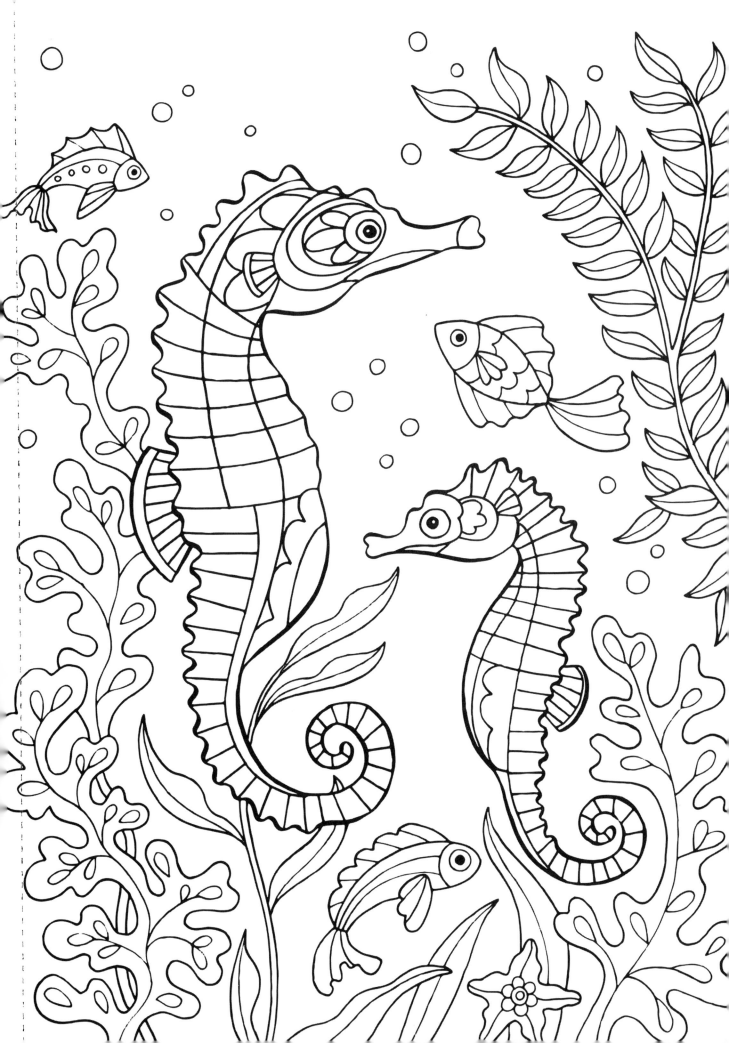

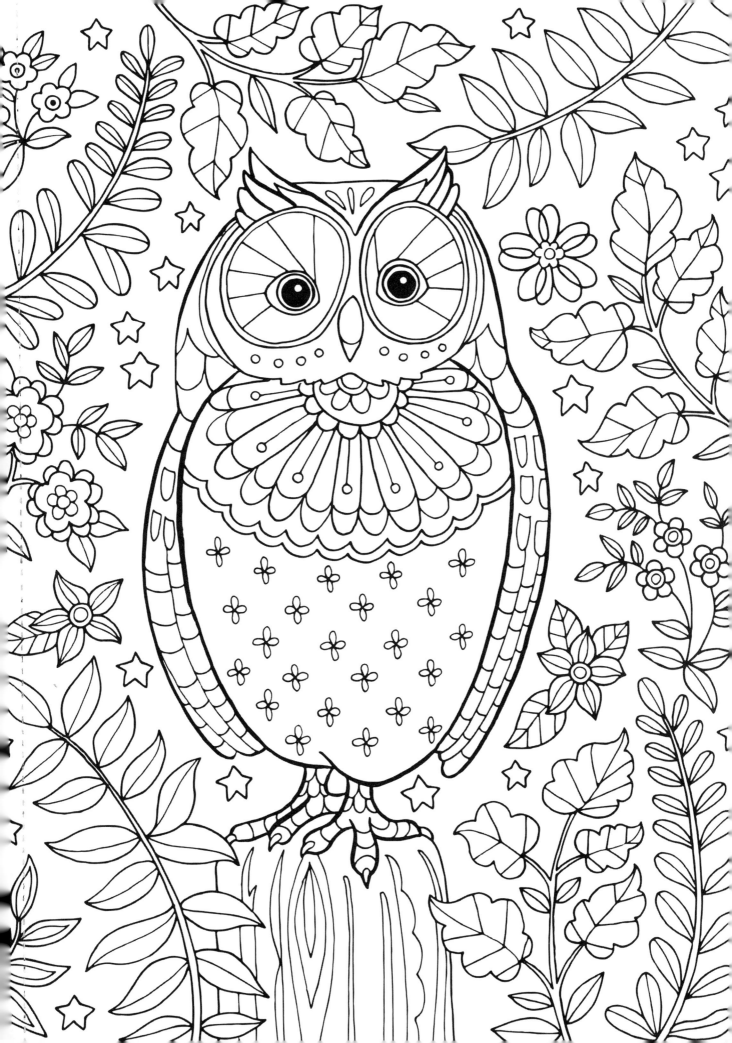

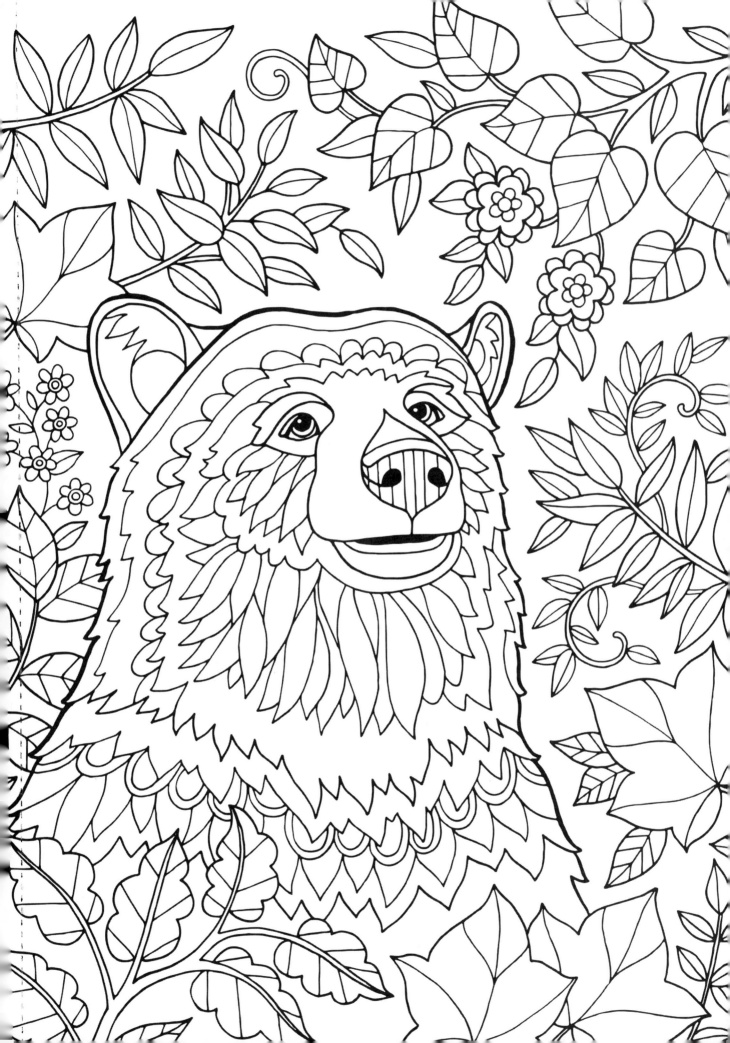

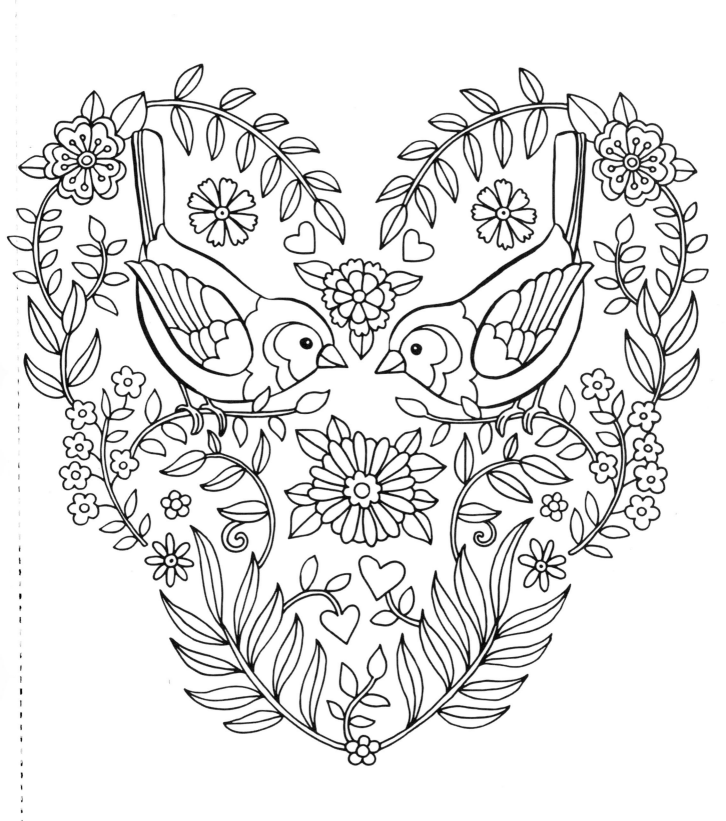

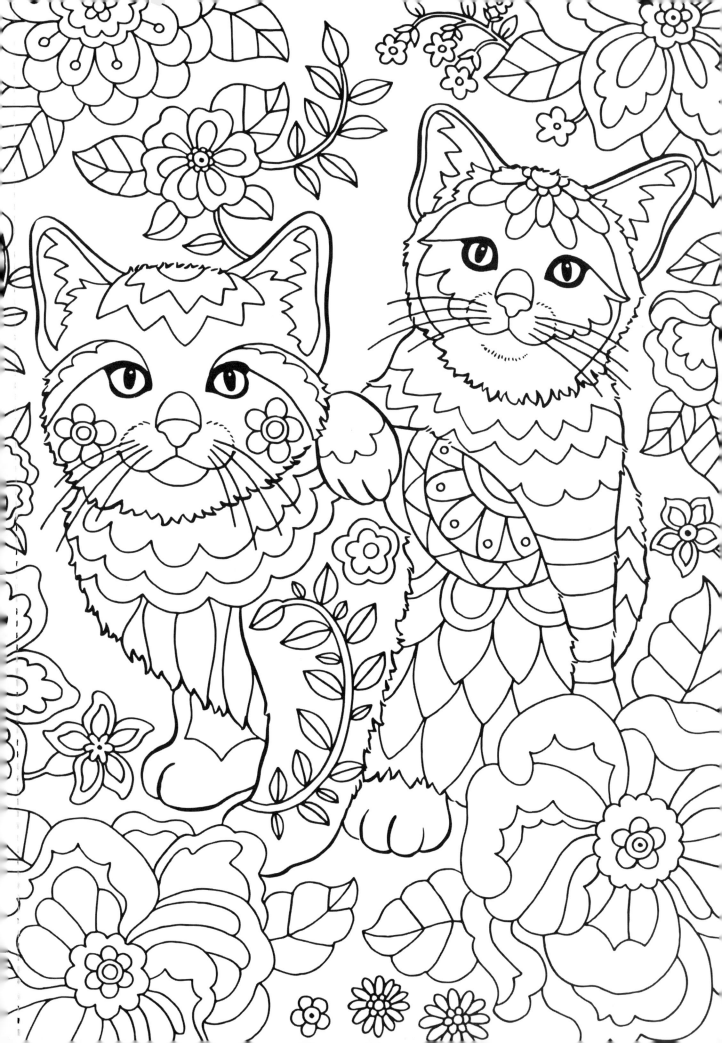

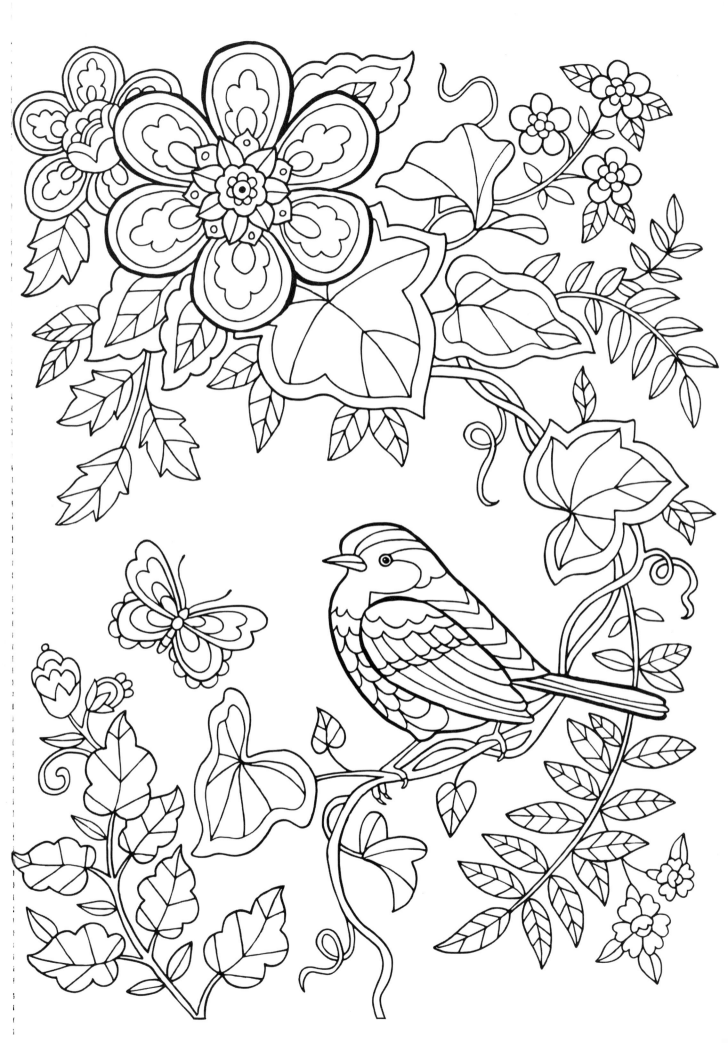

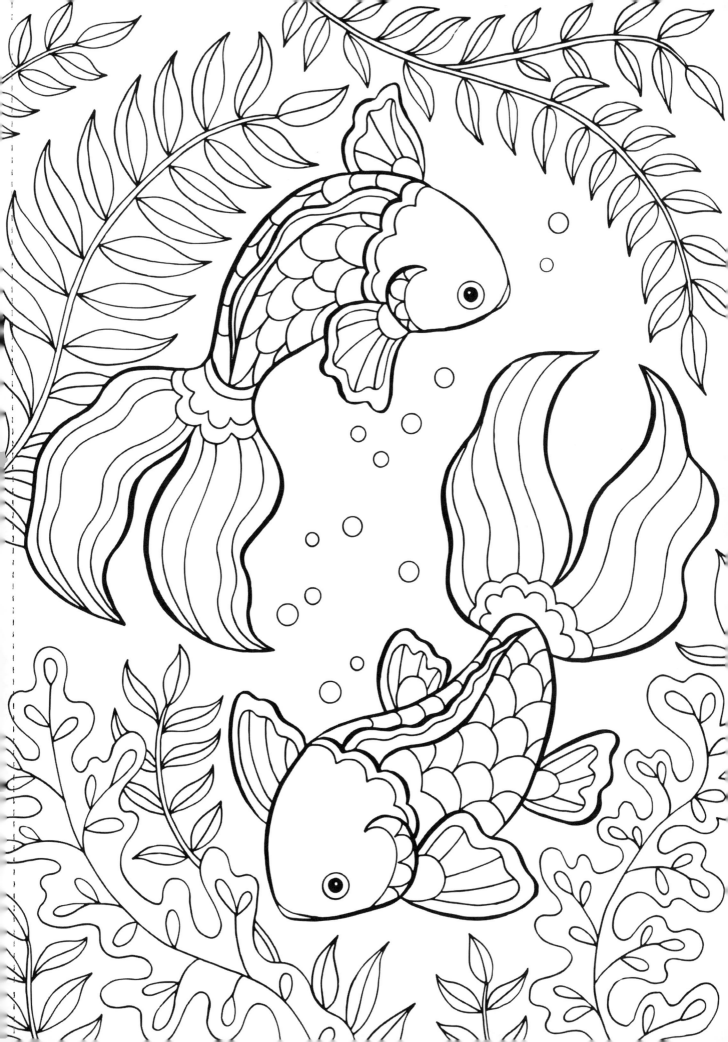

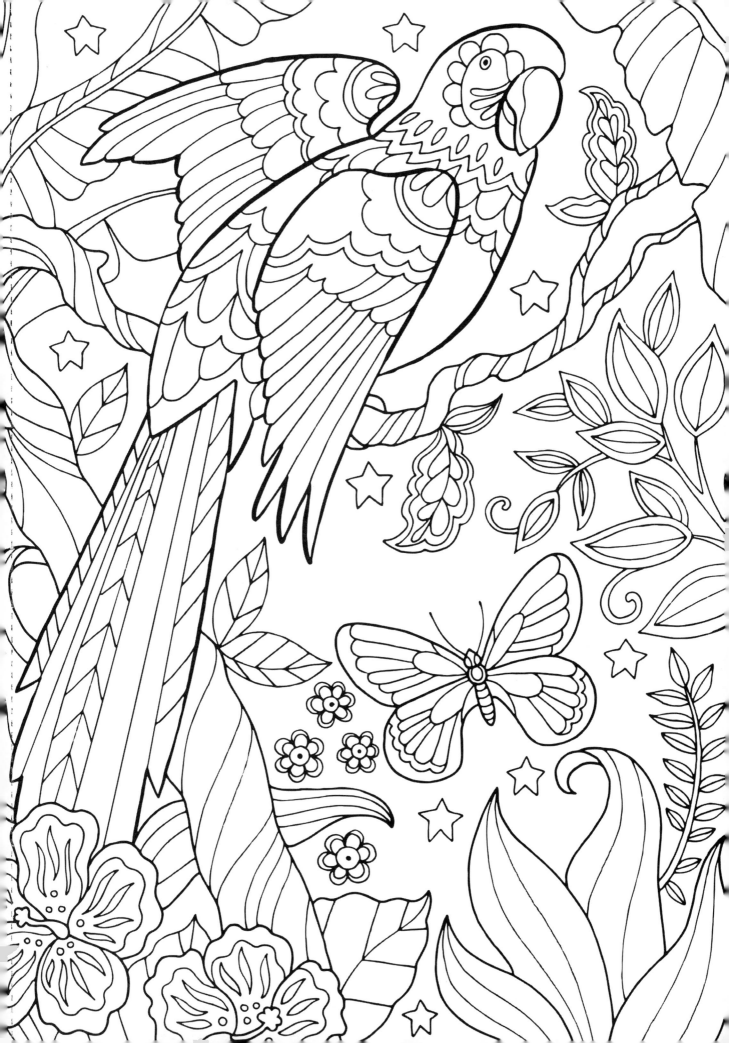

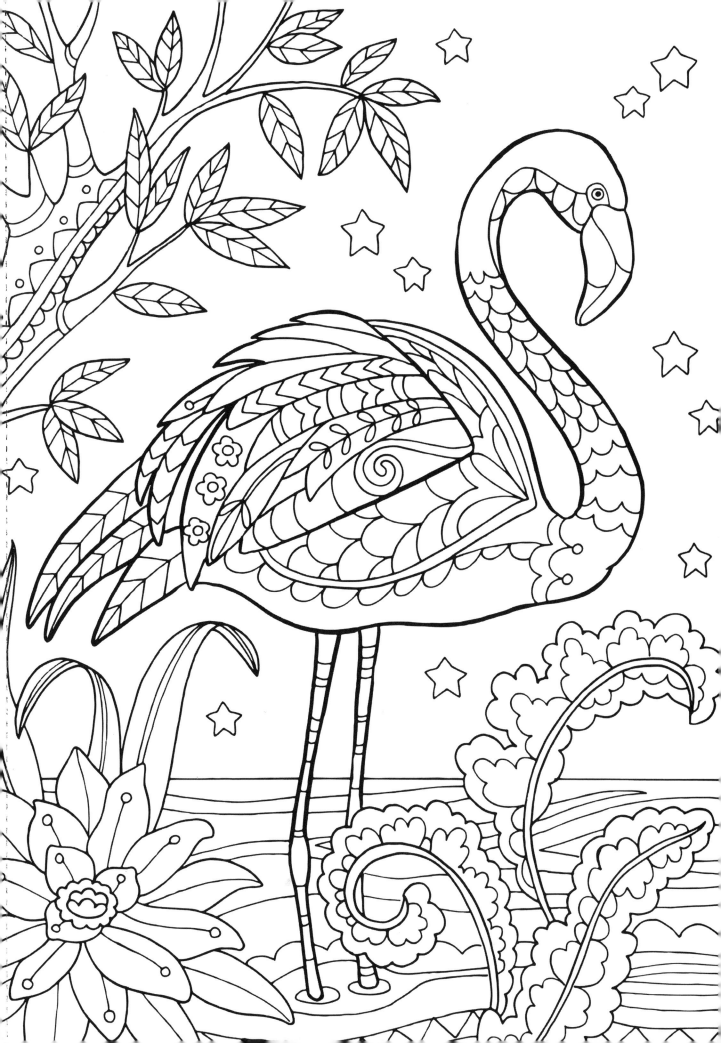

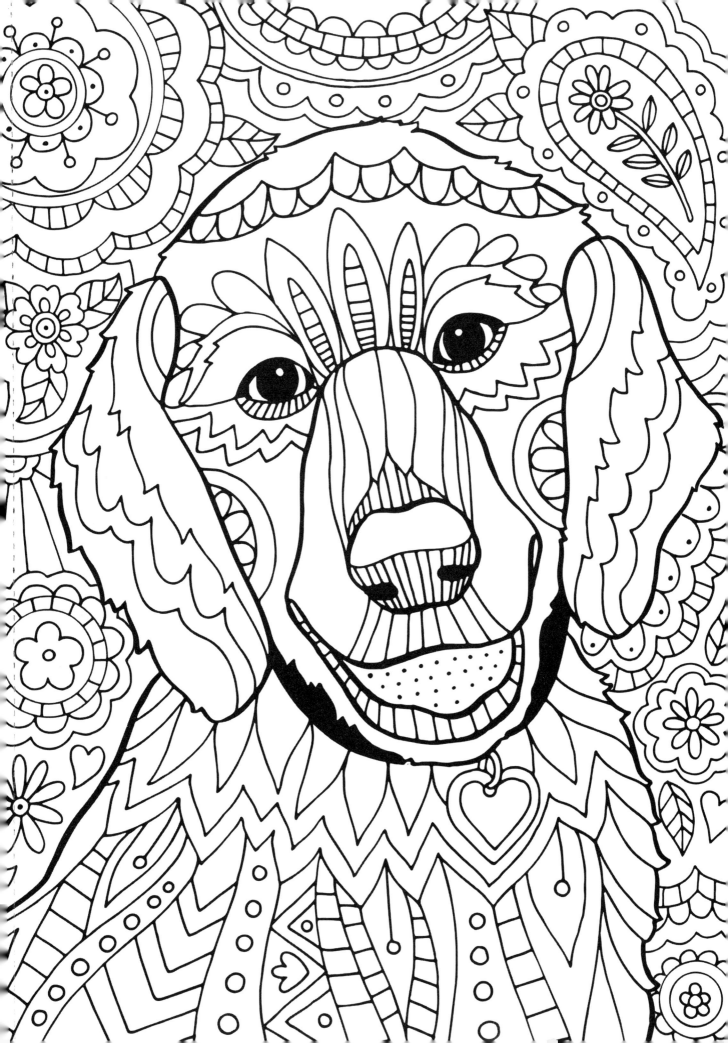

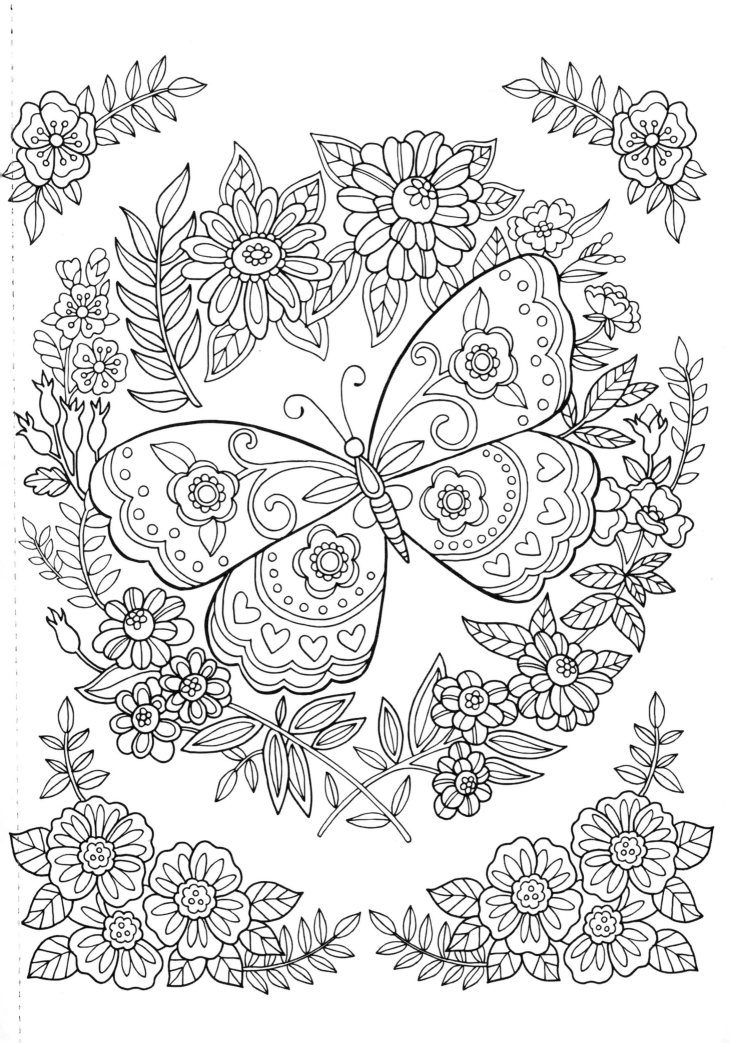

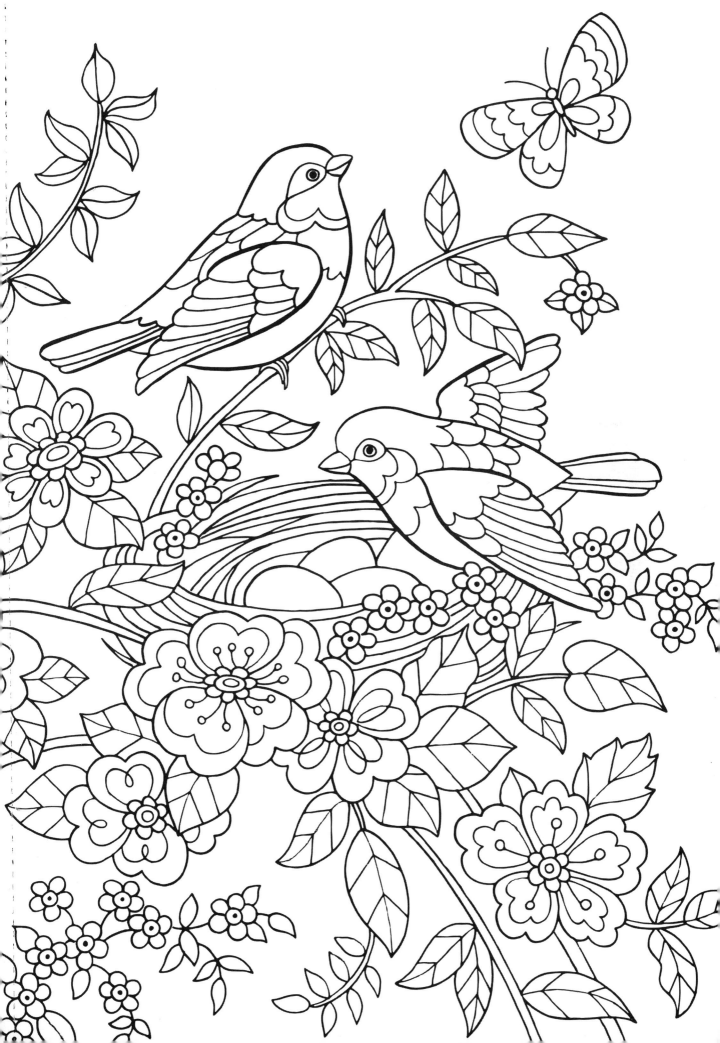

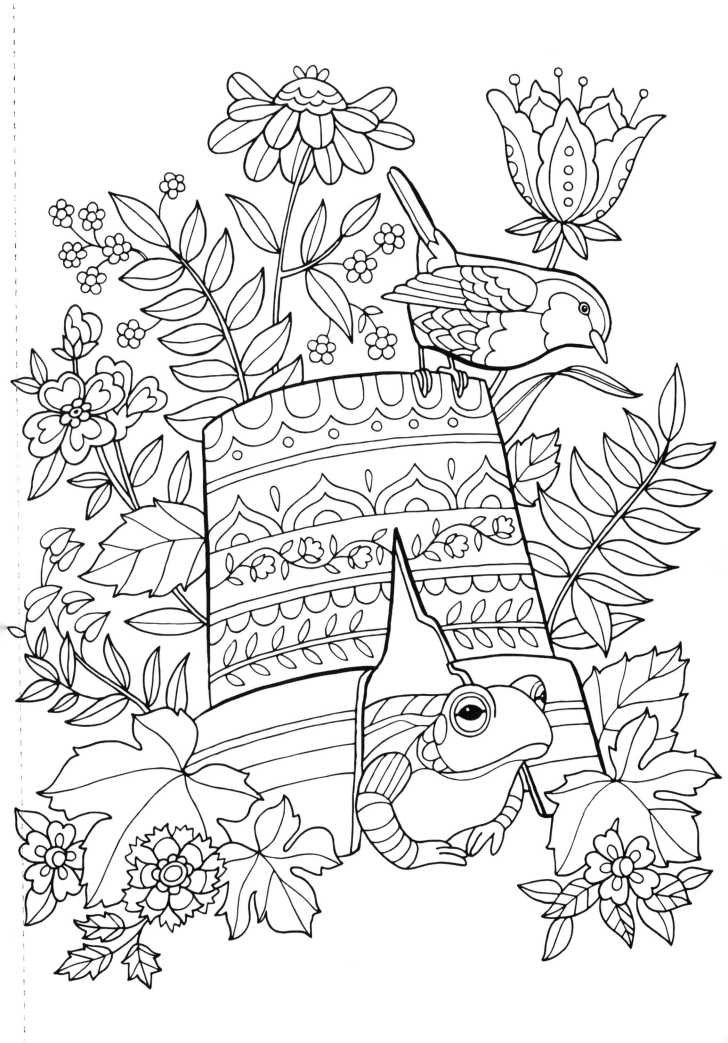

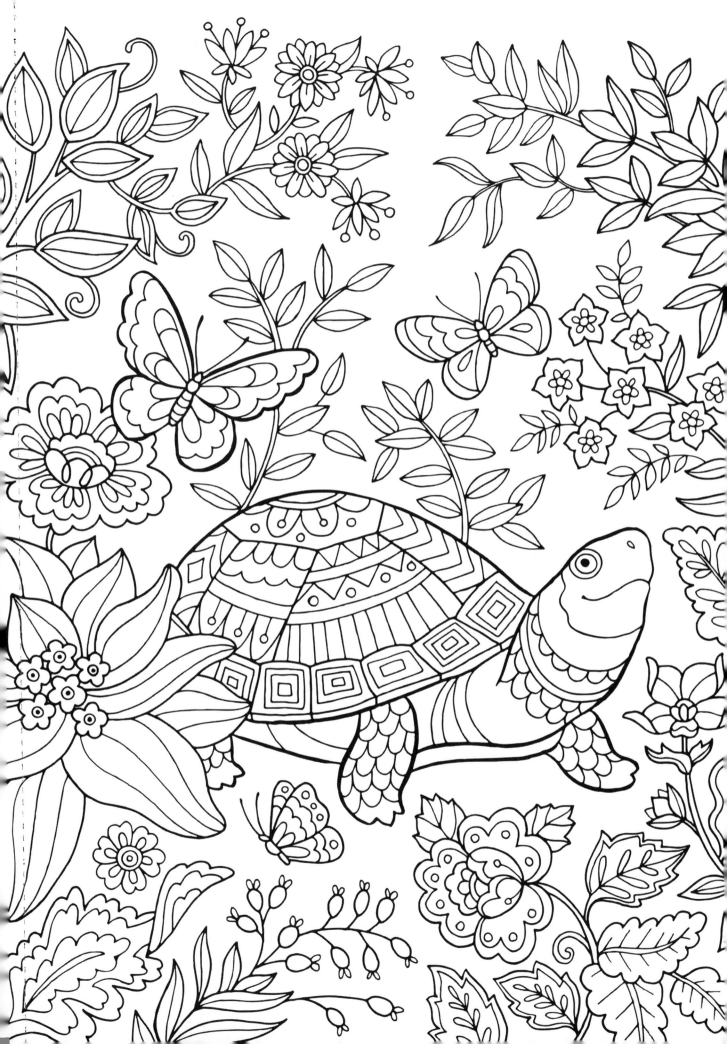

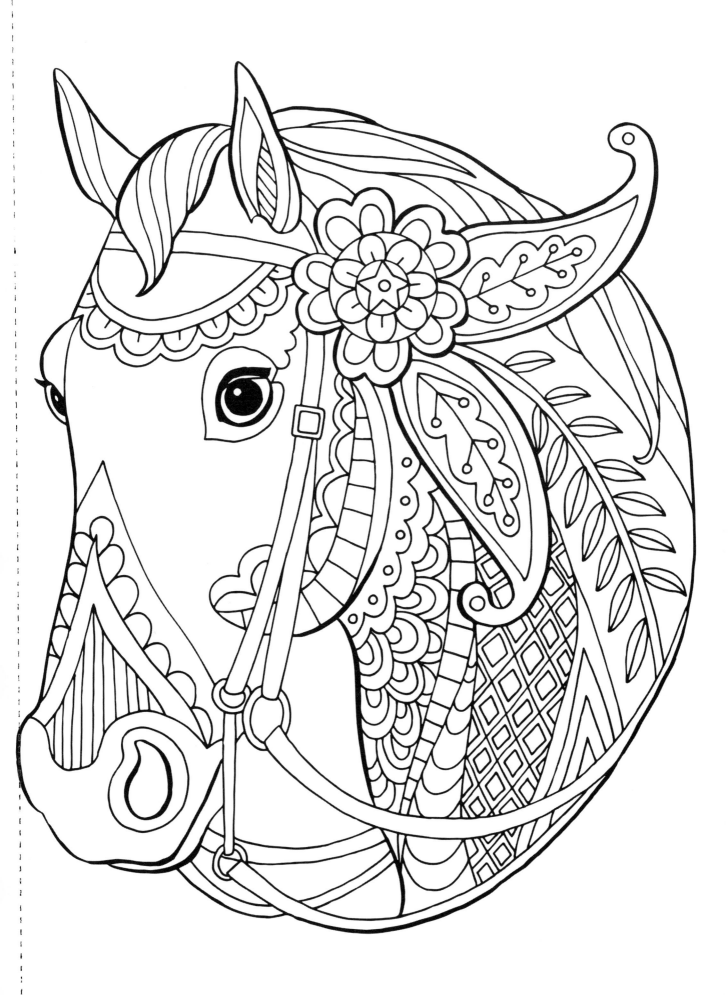

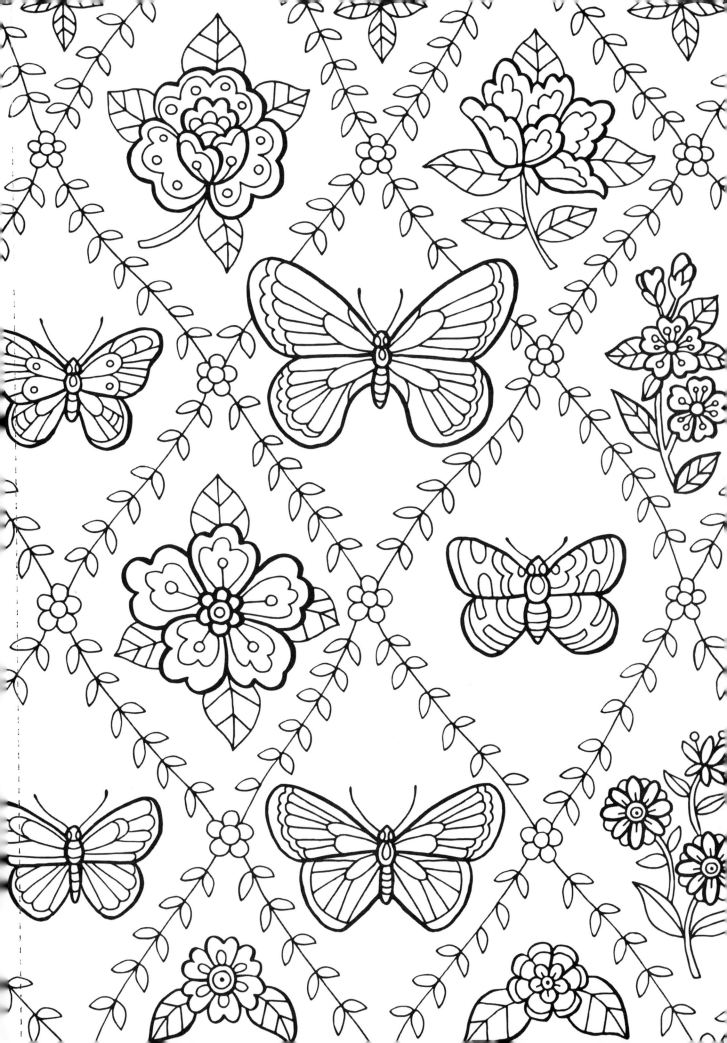

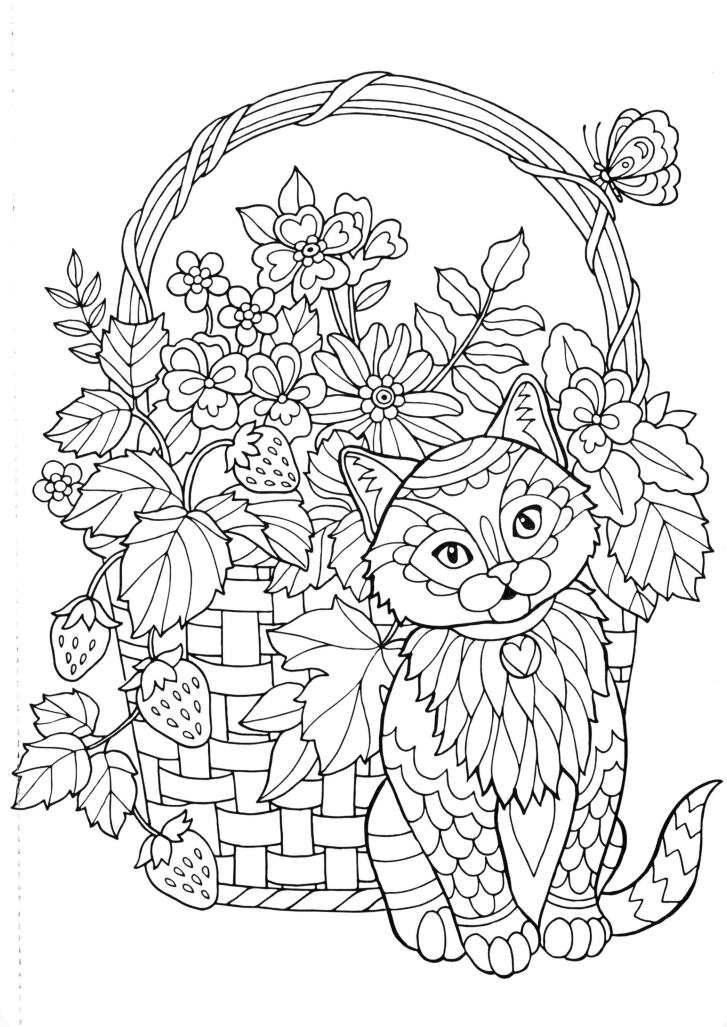

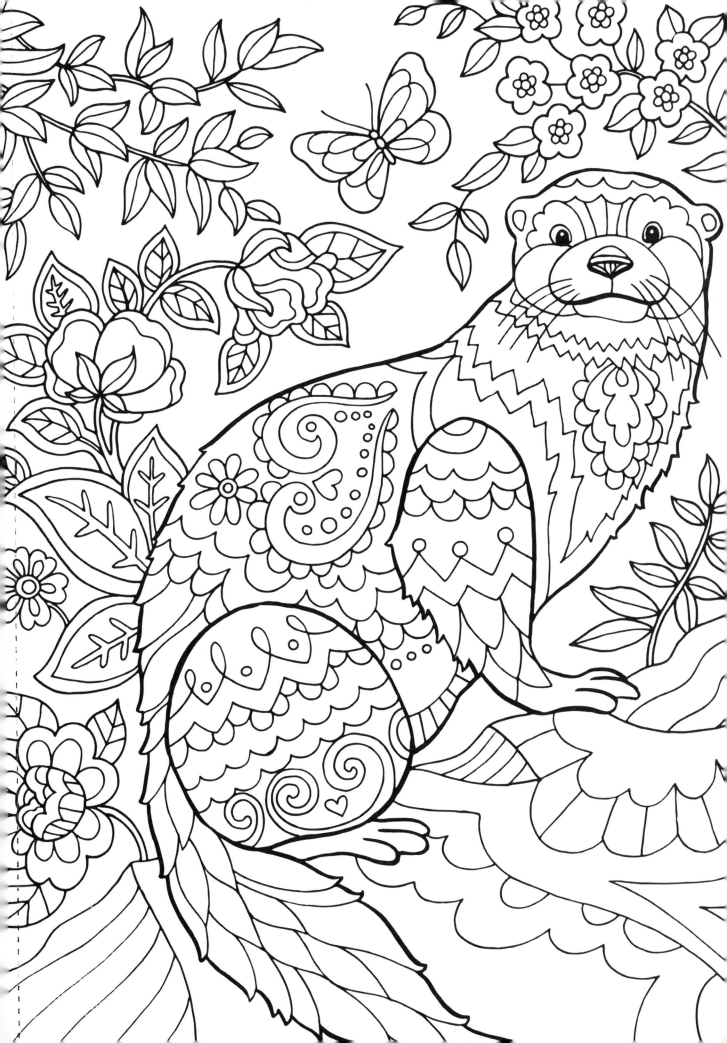

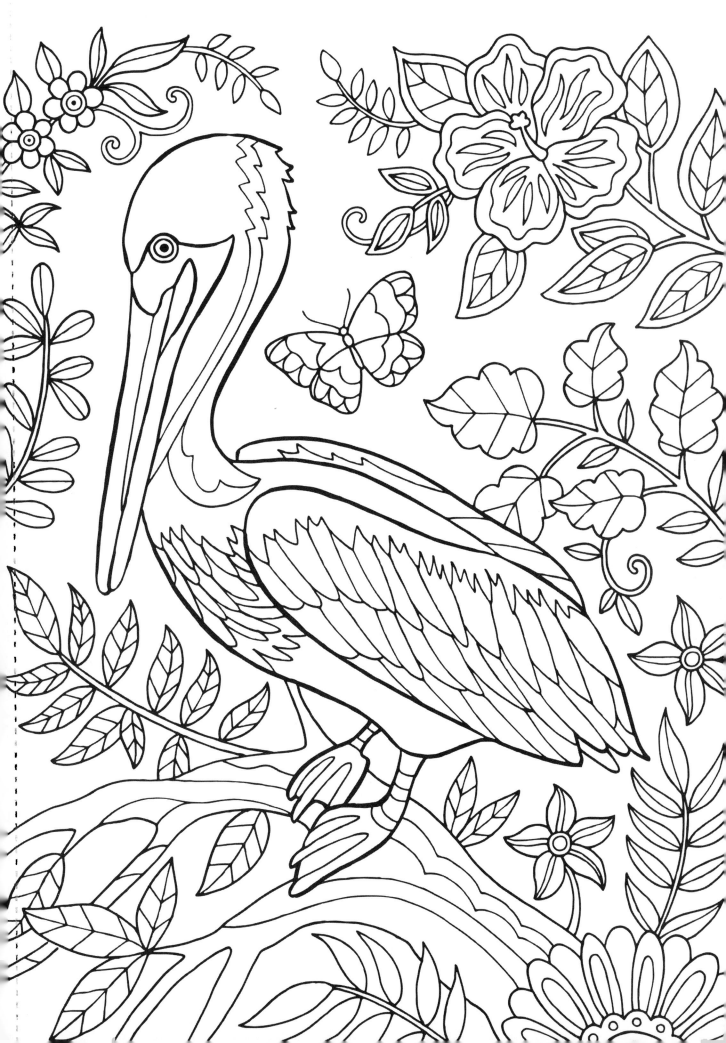

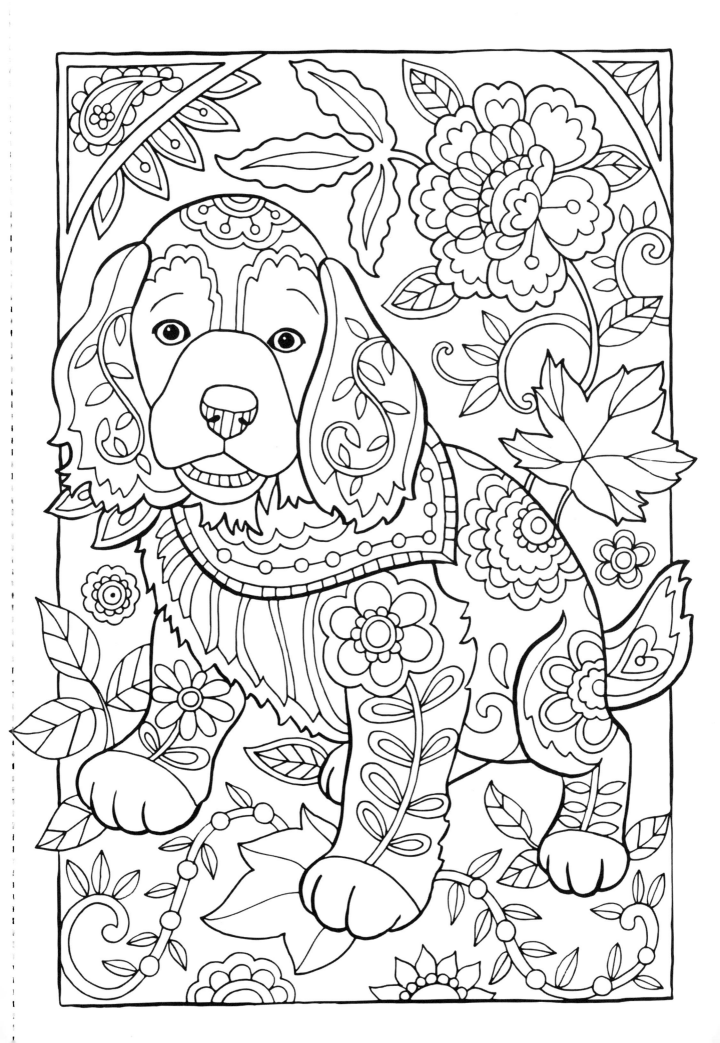

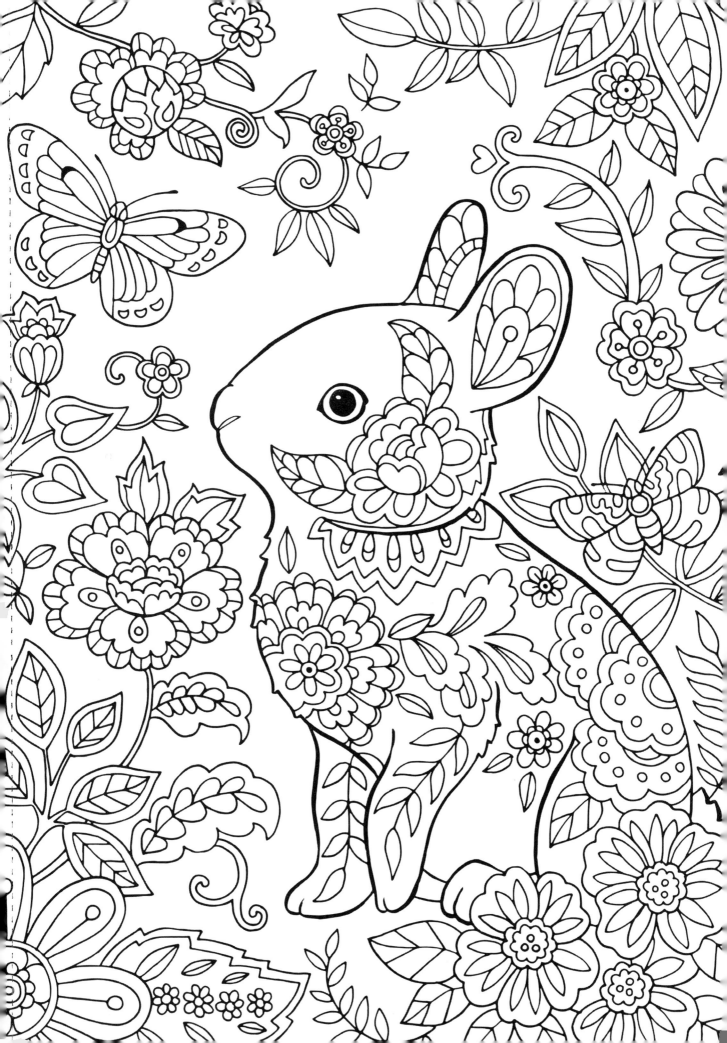

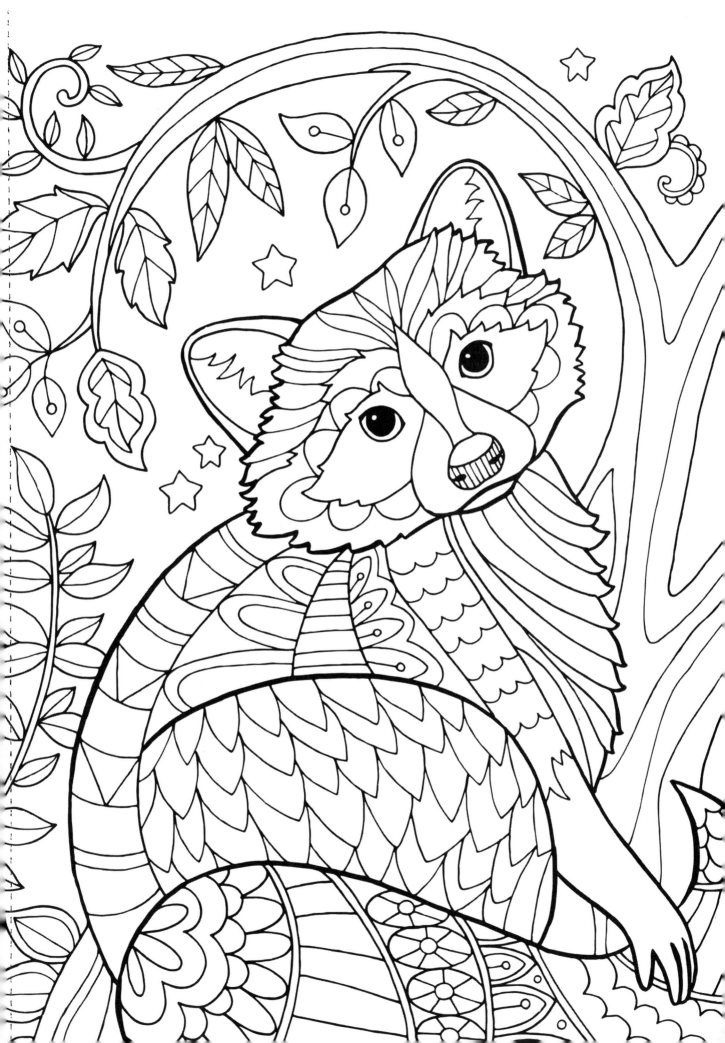

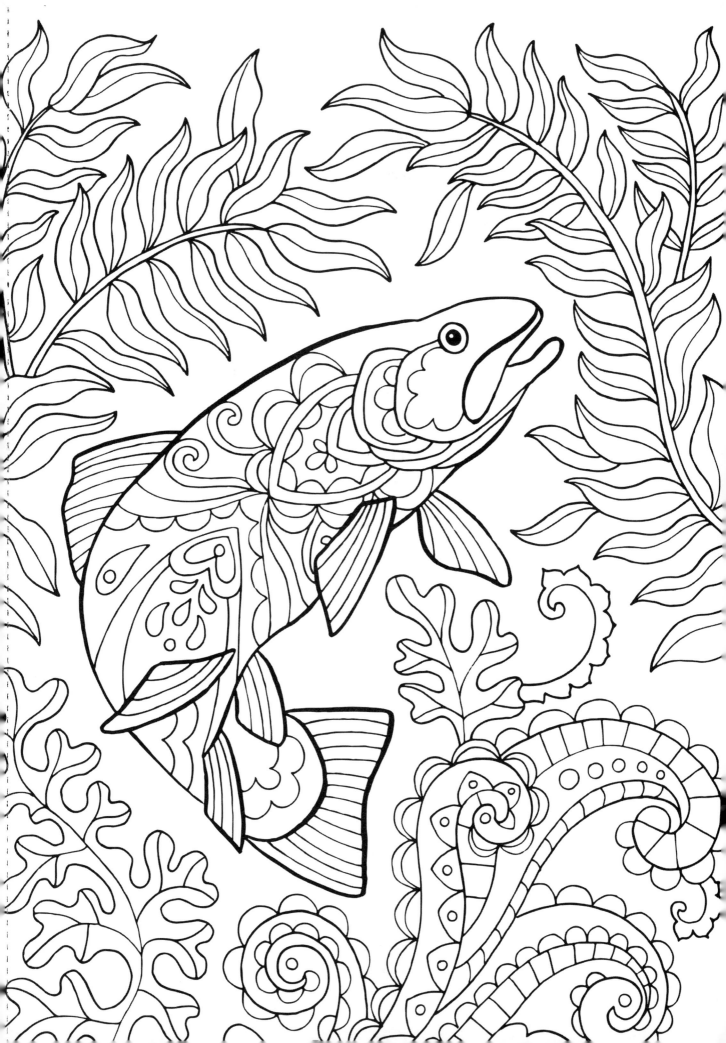

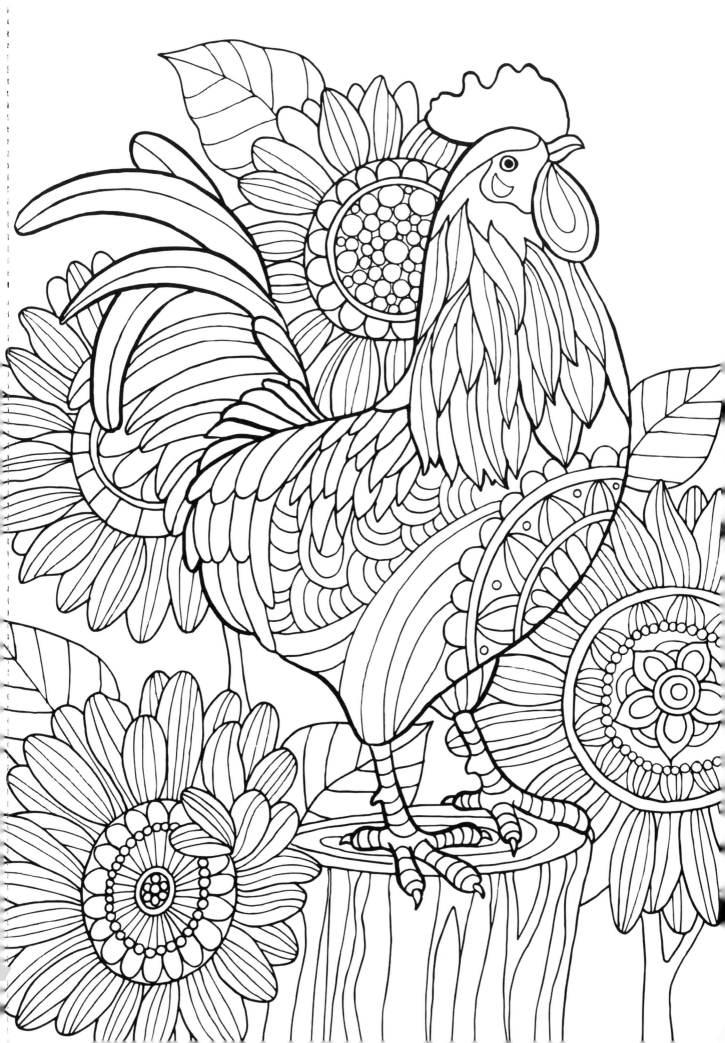

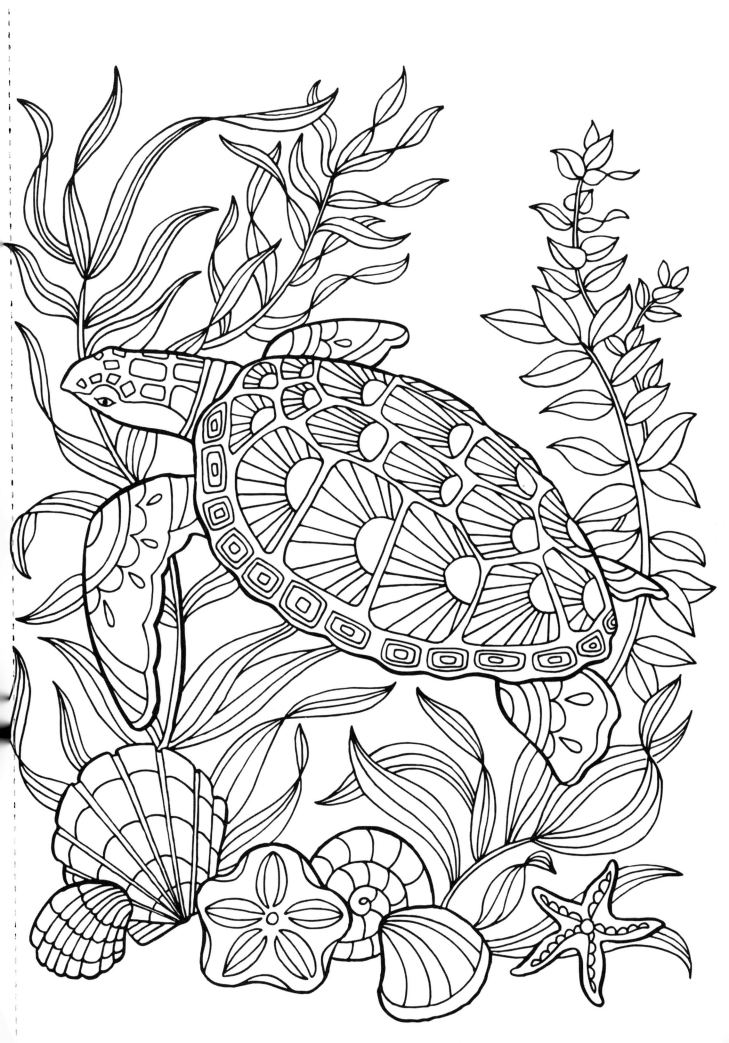

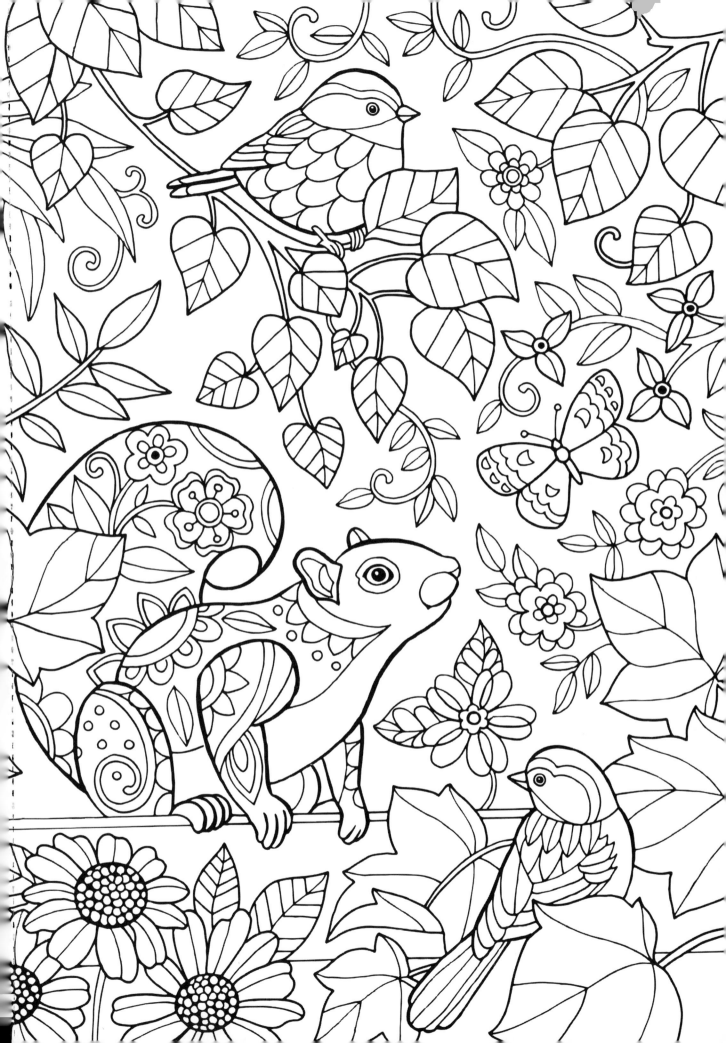

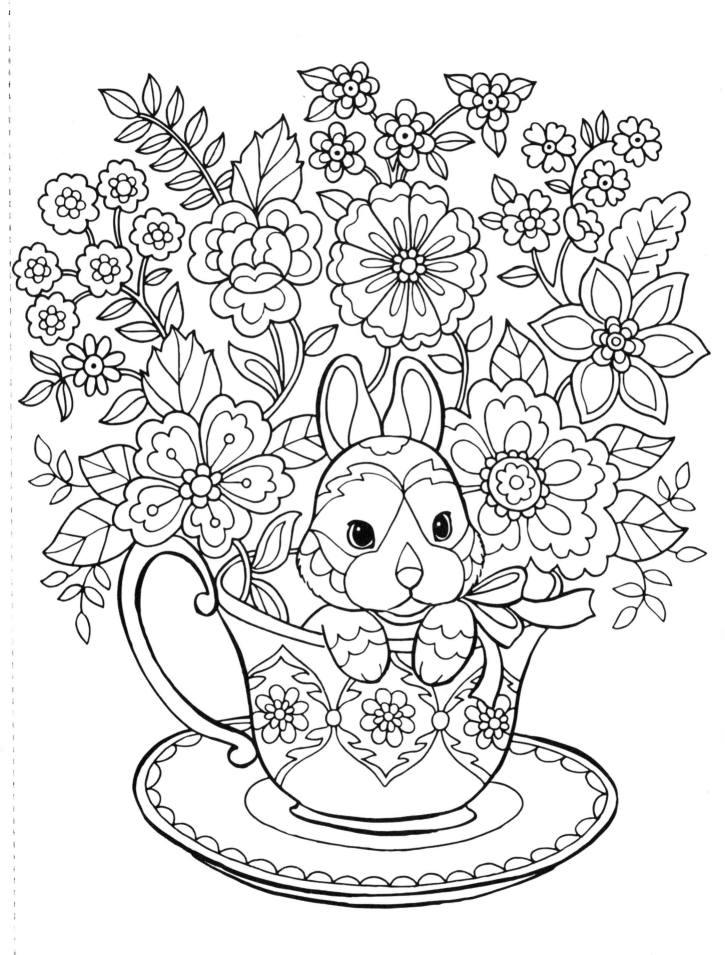

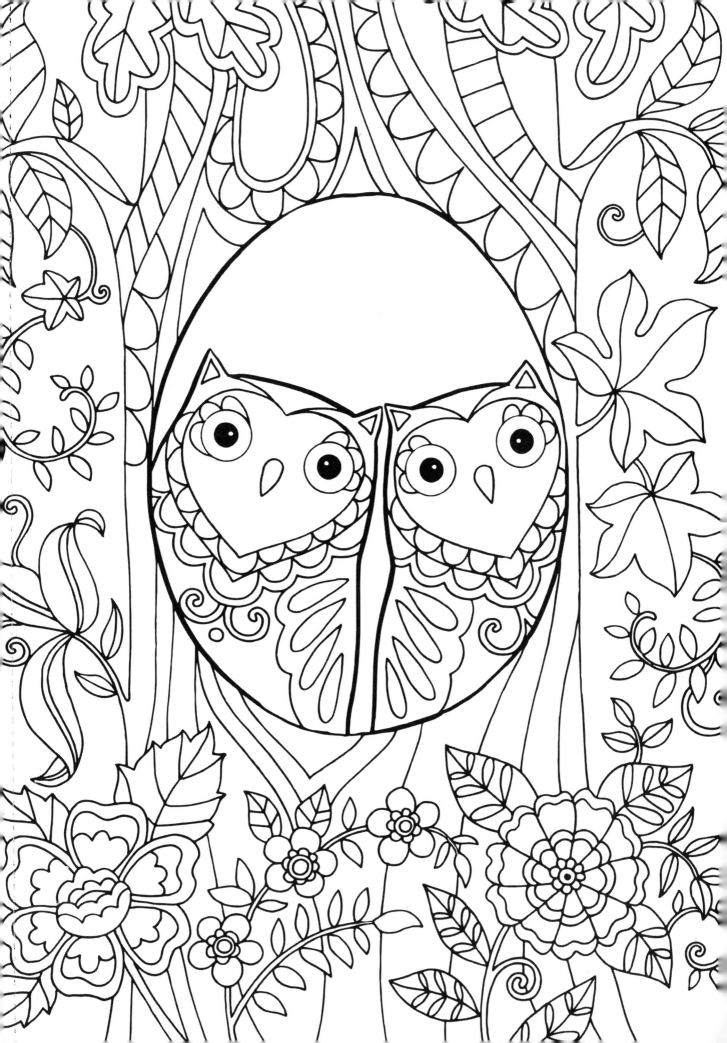

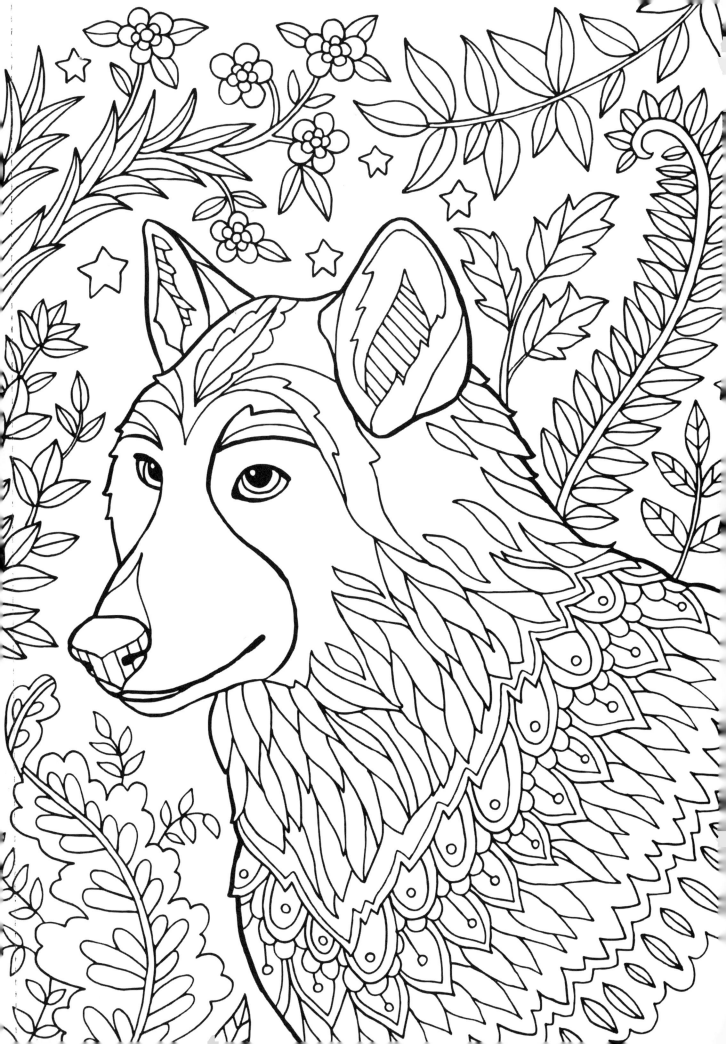

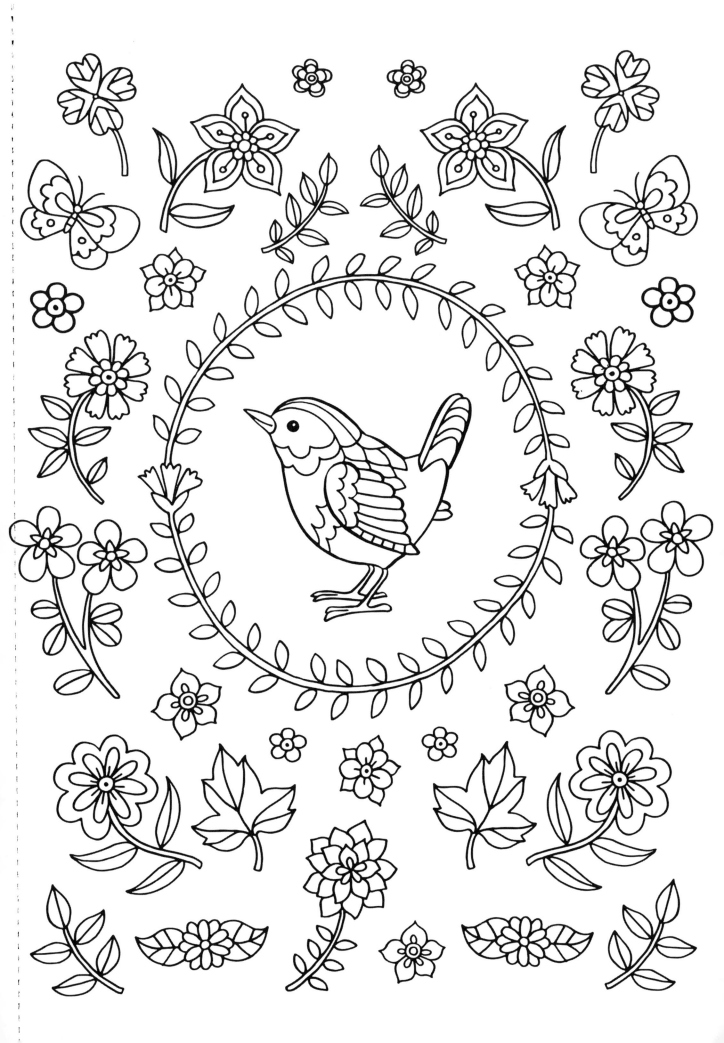

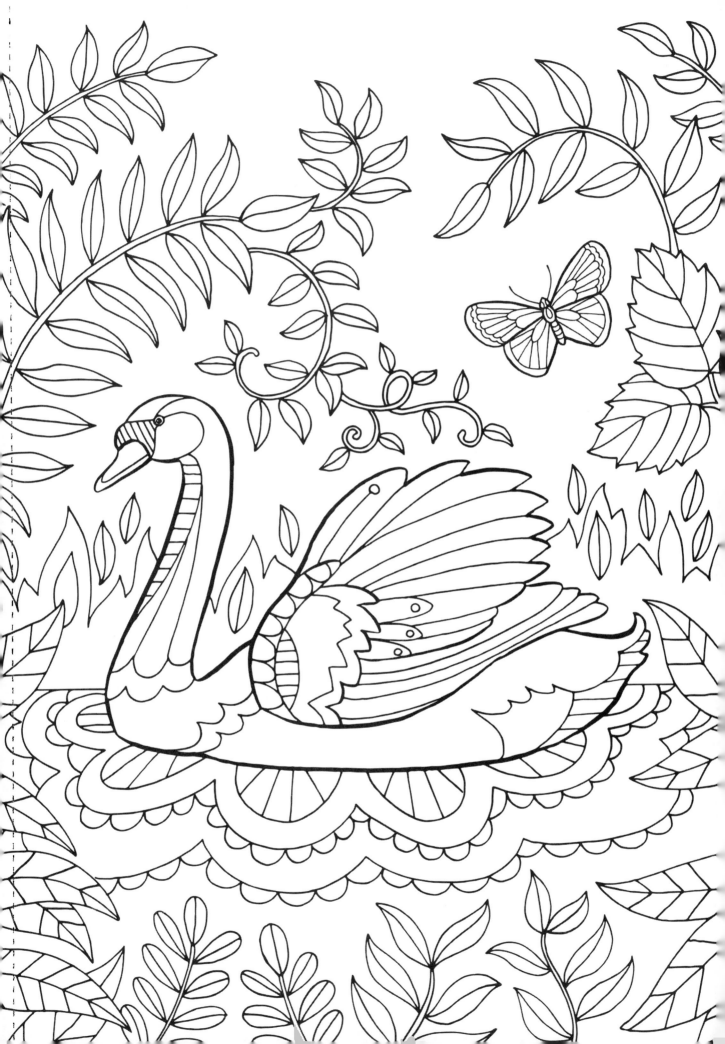

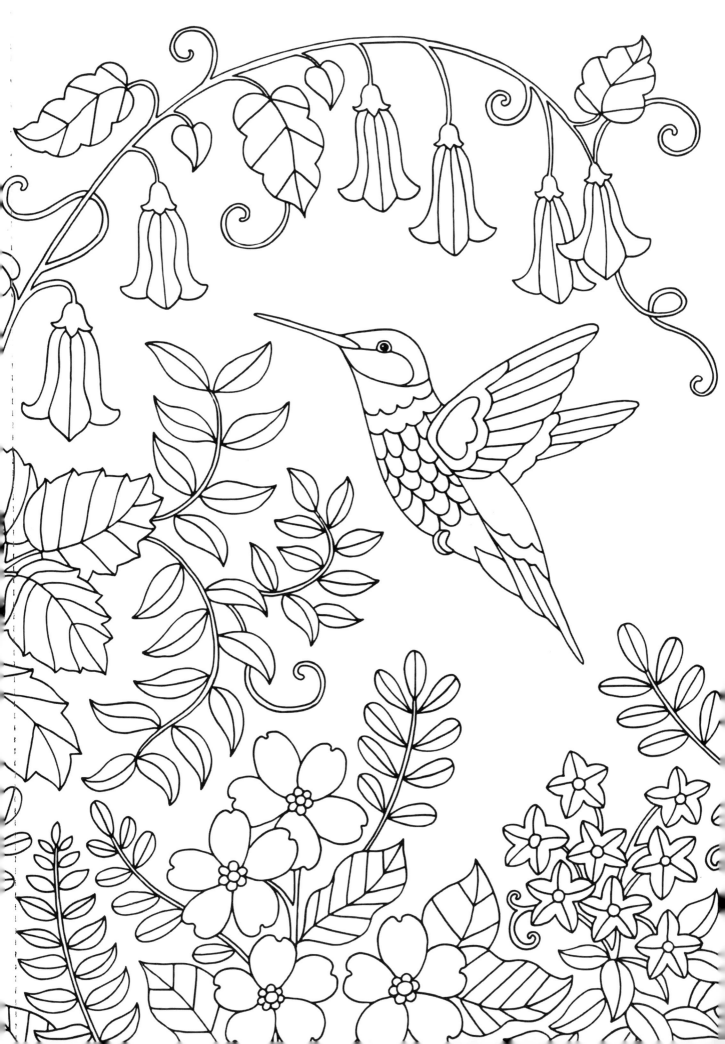

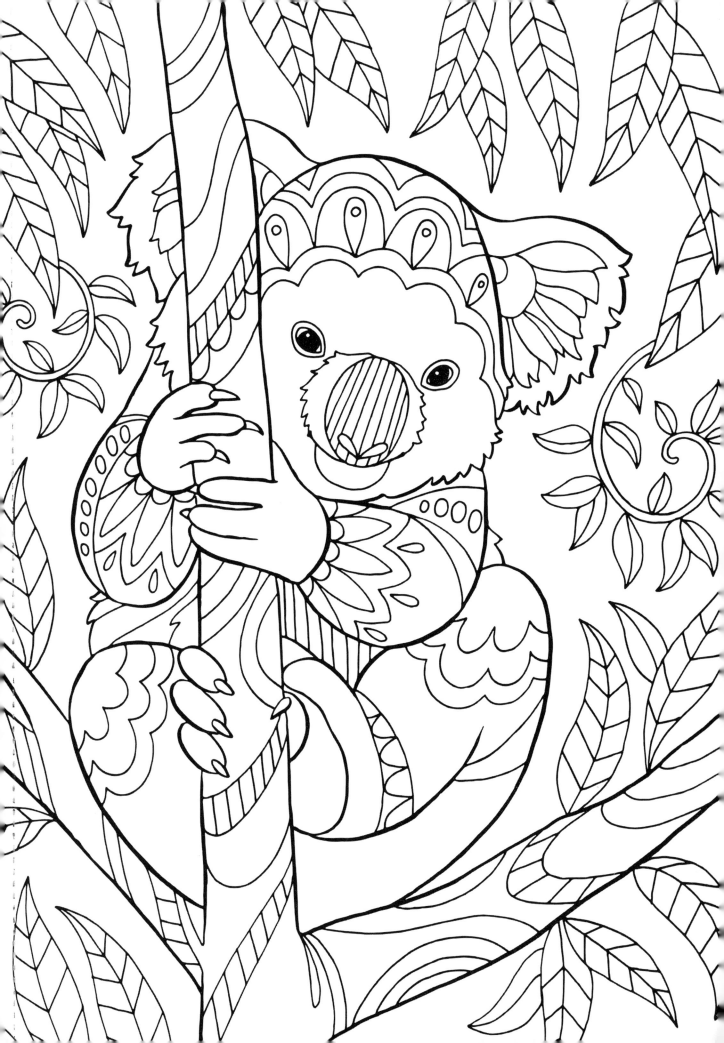

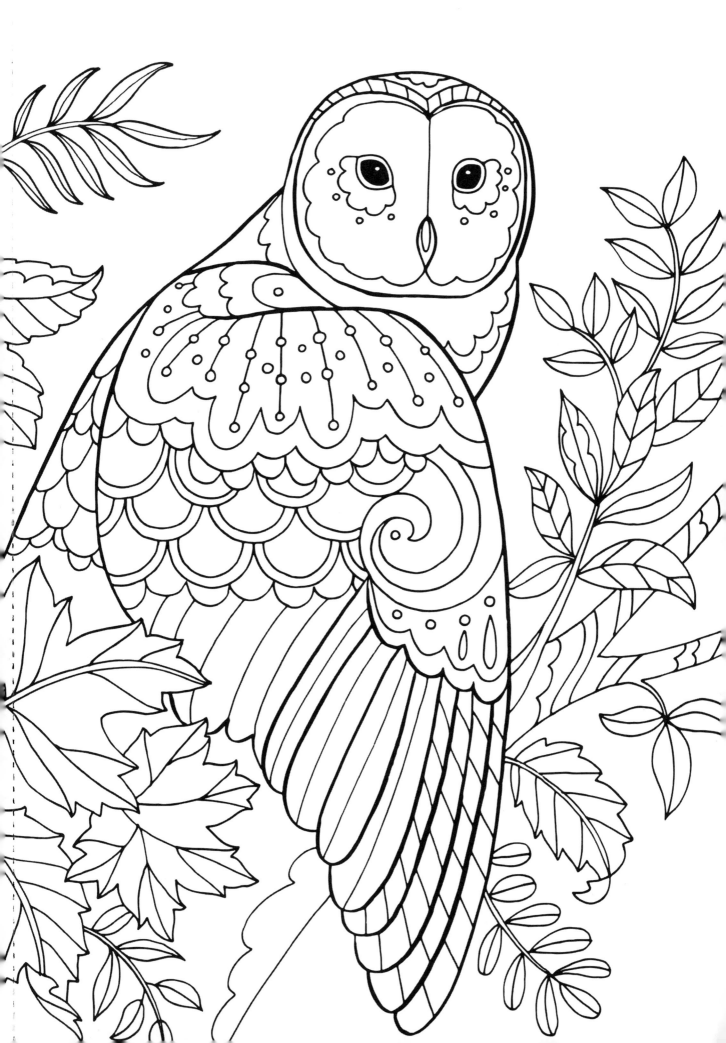

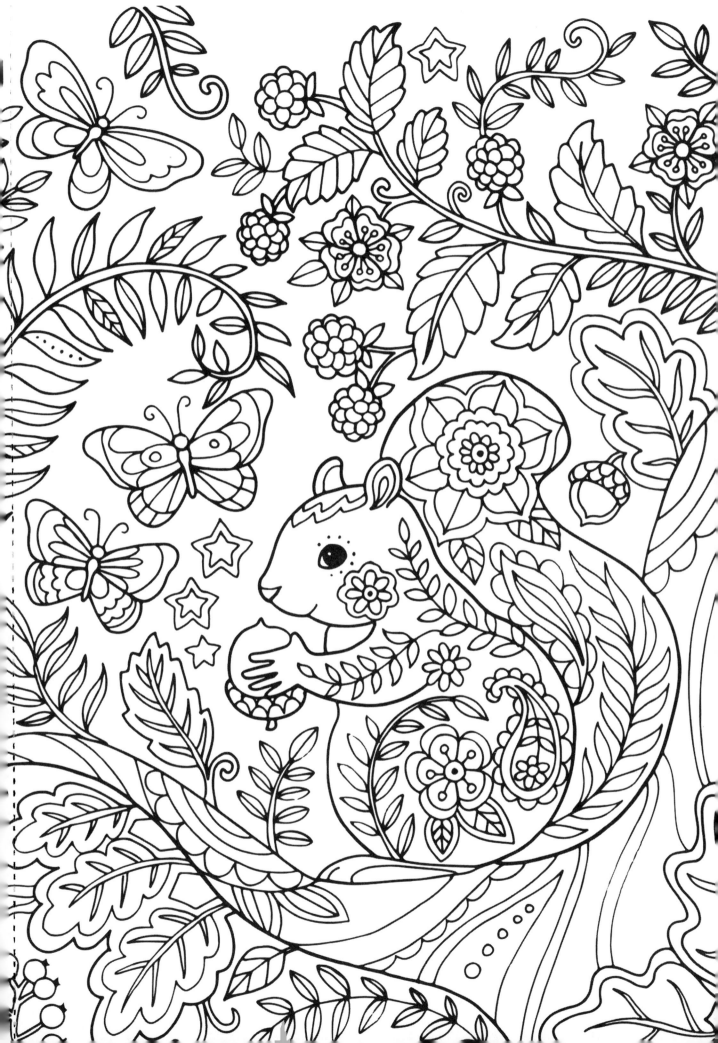

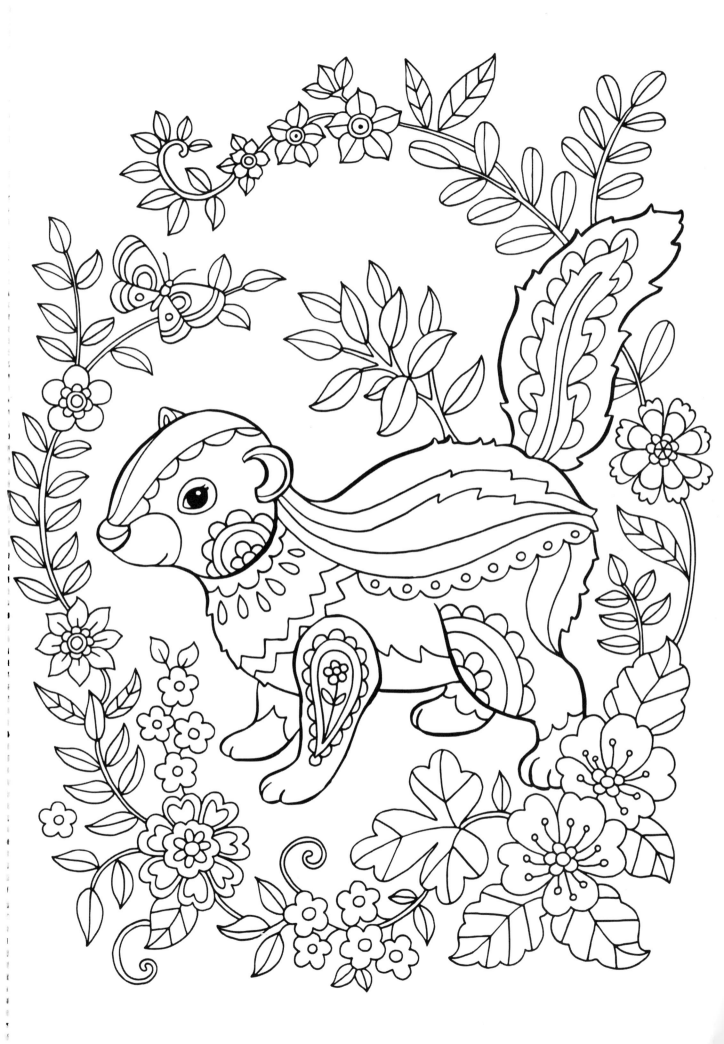

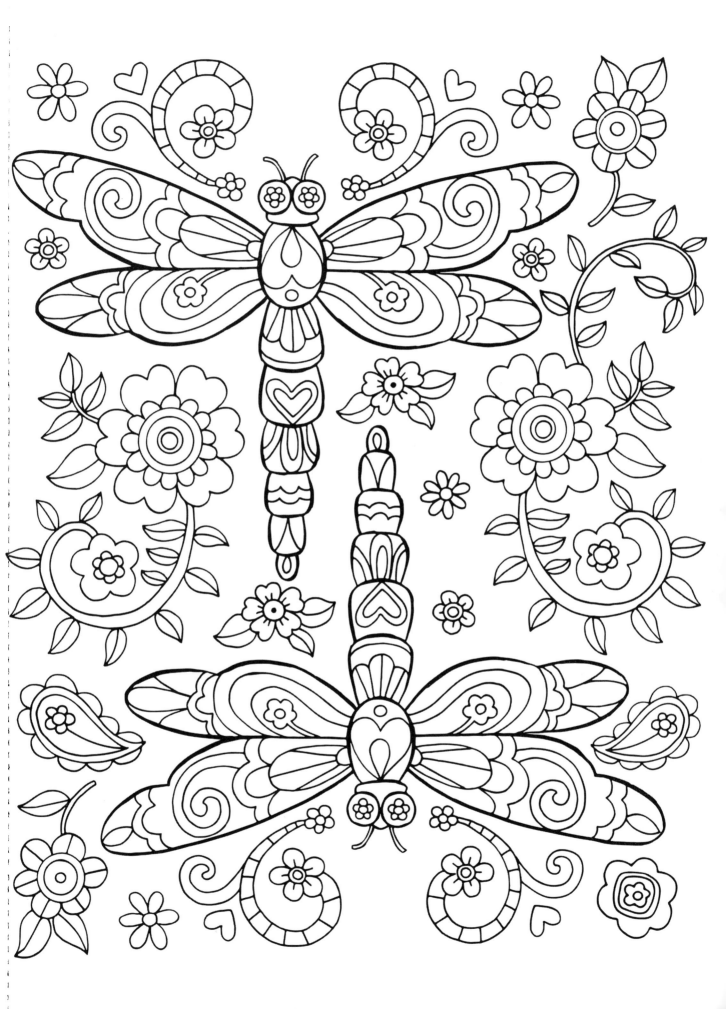

ABOUT THE AUTHOR

Born in England and raised in the United States, Jane Maday has been a professional artist since she was 14 years old. At 16, she was hired by the University of Florida as a scientific illustrator. After graduating from the Ringling College of Art and Design, Jane was recruited by Hallmark Cards, Inc., as a greeting card illustrator. She left the corporate world after her children were born and now licenses her work for products such as cards, flags, puzzles, gifts and home decor. Jane lives in scenic Colorado with her husband and children. This is her fifth book for North Light.

fw

a content + ecommerce company

Other fine North Light Books are available from your favorite bookstore, art supply store or online supplier. Visit our website at fwmedia.com.

20 19 18 17 5 4 3

DISTRIBUTED IN CANADA BY FRASER DIRECT
100 Armstrong Avenue
Georgetown, ON, Canada L7G 5S4
Tel: (905) 877-4411

DISTRIBUTED IN THE U.K. AND EUROPE
BY F&W MEDIA INTERNATIONAL LTD
Brunel House, Forde Close, Newton Abbot, TQ12 4PU, UK
Tel: (+44) 1626 323200, Fax: (+44) 1626 323319
Email: enquiries@fwmedia.com

DISTRIBUTED IN AUSTRALIA BY CAPRICORN LINK
P.O. Box 704, S. Windsor NSW, 2756 Australia
Tel: (02) 4560-1600; Fax: (02) 4577 5288
Email: books@capricornlink.com.au

ISBN 13: 978-1-4403-4662-0

Edited by Beth Erikson
Designed by Breanna Loebach
Production coordinated by Jennifer Bass

DEDICATION

For my son Ian and daughter Margaret, because they bring color to my life. And for my mother Jean and sister Anne, in hopes that they have hours of fun with this book!

ACKNOWLEDGMENTS

Many thanks to the team at North Light, especially Beth, Mona and Jamie!

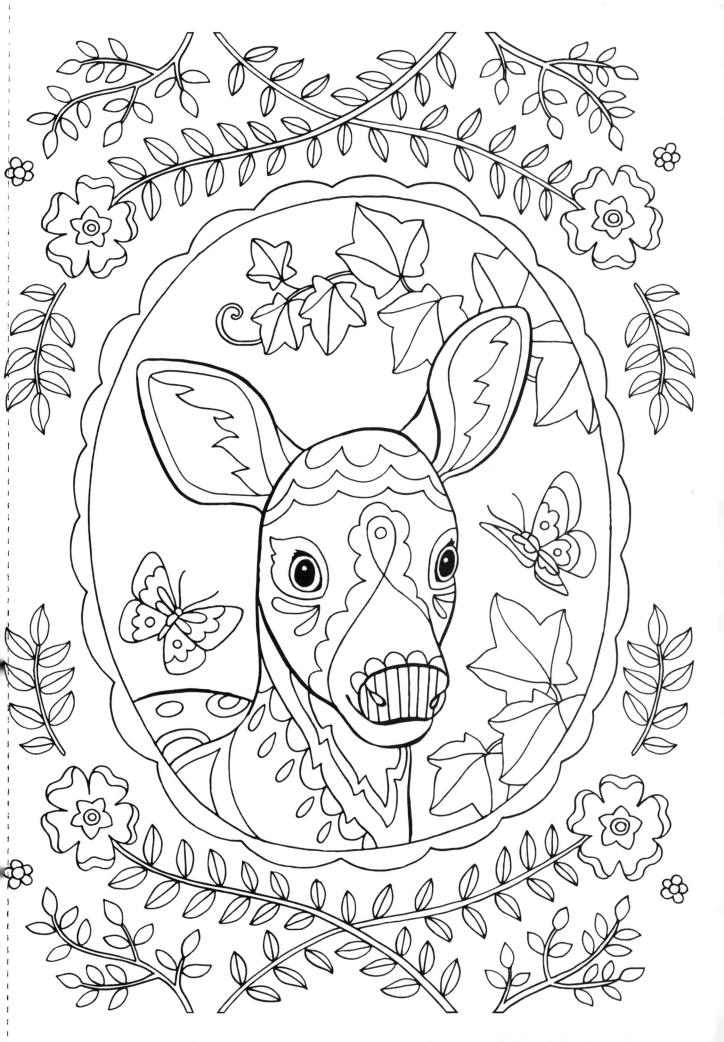

IDEAS.
INSTRUCTION.
INSPIRATION.

These and other fine North Light products are available at your favorite art & craft retailer, bookstore or online supplier. Visit our websites at artistsnetwork.com and artistsnetwork.tv.

Follow North Light Books for the latest news, free wallpapers, free demos and chances to win FREE BOOKS!

GET YOUR ART IN PRINT!

Visit **artistsnetwork.com/ splashwatercolor** for up-to-date information on *Splash* and other North Light competitions.

Receive FREE downloadable bonus materials when you sign up for our free newsletter at **artistsnetwork.com/ Newsletter_Thanks.**